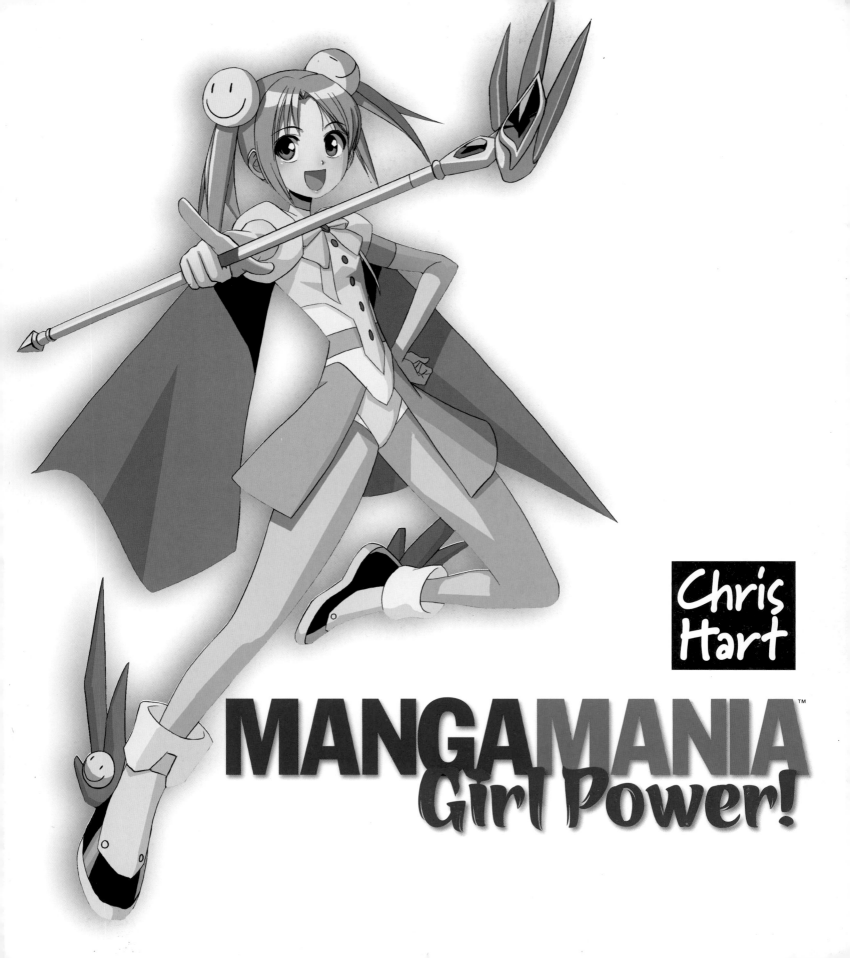

Chris Hart

MANGAMANIA
Girl Power!

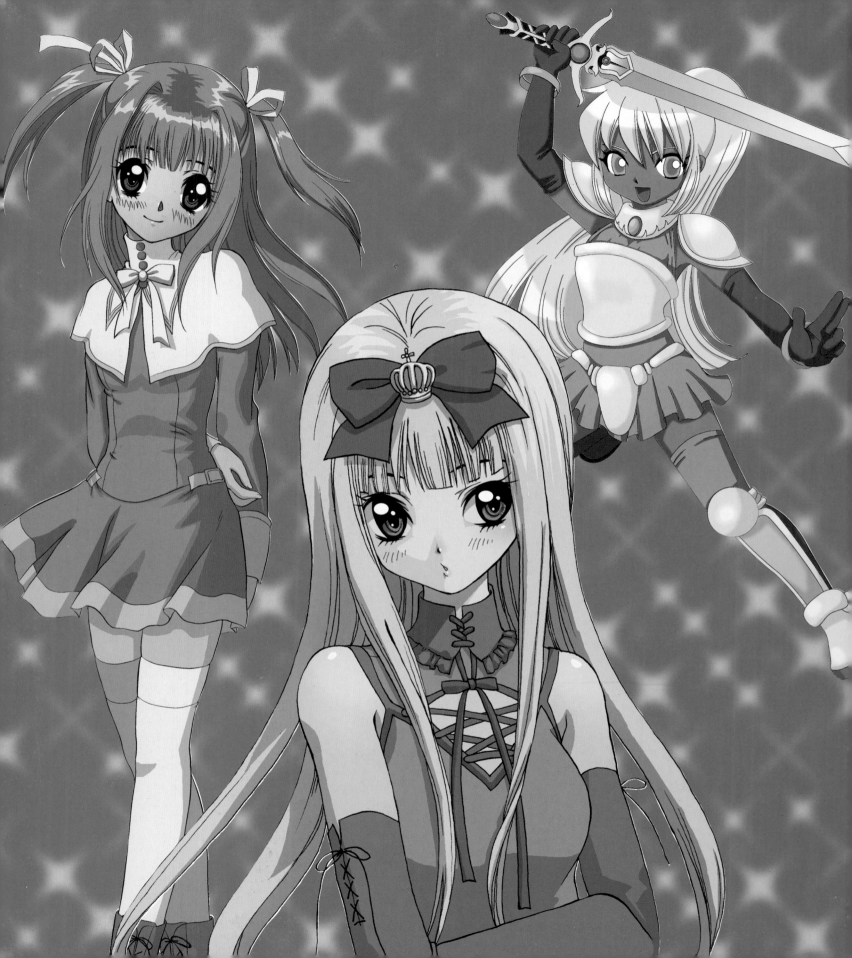

Chris Hart

MANGAMANIA™
Girl Power!

drawing fabulous females
for Japanese comics

Chris Hart Books

An imprint of
Sixth&Spring Books
233 Spring St.
New York, NY 10013

Book Division Manager
WENDY WILLIAMS

Senior Editor
MICHELLE BREDESON

Art Director
DIANE LAMPHRON

Associate Art Director
SHEENA T. PAUL

Copy Editor
KRISTINA SIGLER

Cover Design
DIANE LAMPHRON

Book Design
DAVID R. WOLF

Cover Color
MADA DESIGN, INC.

Interior Color
ROMULO FAJARDO

Contributing Artists
DENISE AKEMI
ANZU
MAKIKO KANADA
IDUMI KIMURAYA
CHIHIRO MILLEY
ROBERTA PARES
JENNYSON ROSERO
KRISS SISON
NAO YAZAWA

Vice President, Publisher
TRISHA MALCOLM

Production Manager
DAVID JOINNIDES

Creative Director
JOE VIOR

President
ART JOINNIDES

chrishartbooks.com

Library of Congress Control Number: 2008936332

ISBN-13: 978-1-933027-79-1
ISBN-10: 1-933027-79-7

Manufactured in China

3 5 7 9 10 8 6 4 2

First Edition

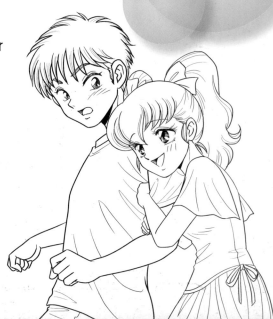

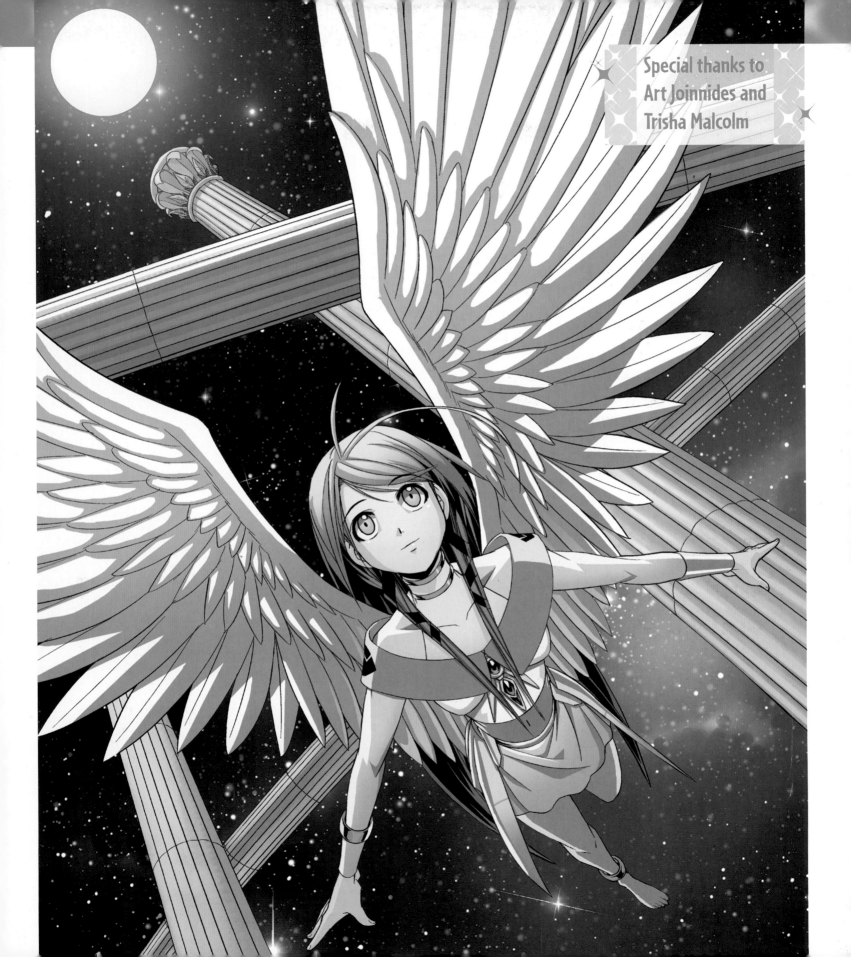

Special thanks to
Art Joinnides and
Trisha Malcolm

Contents

27

13

44

54

92

134

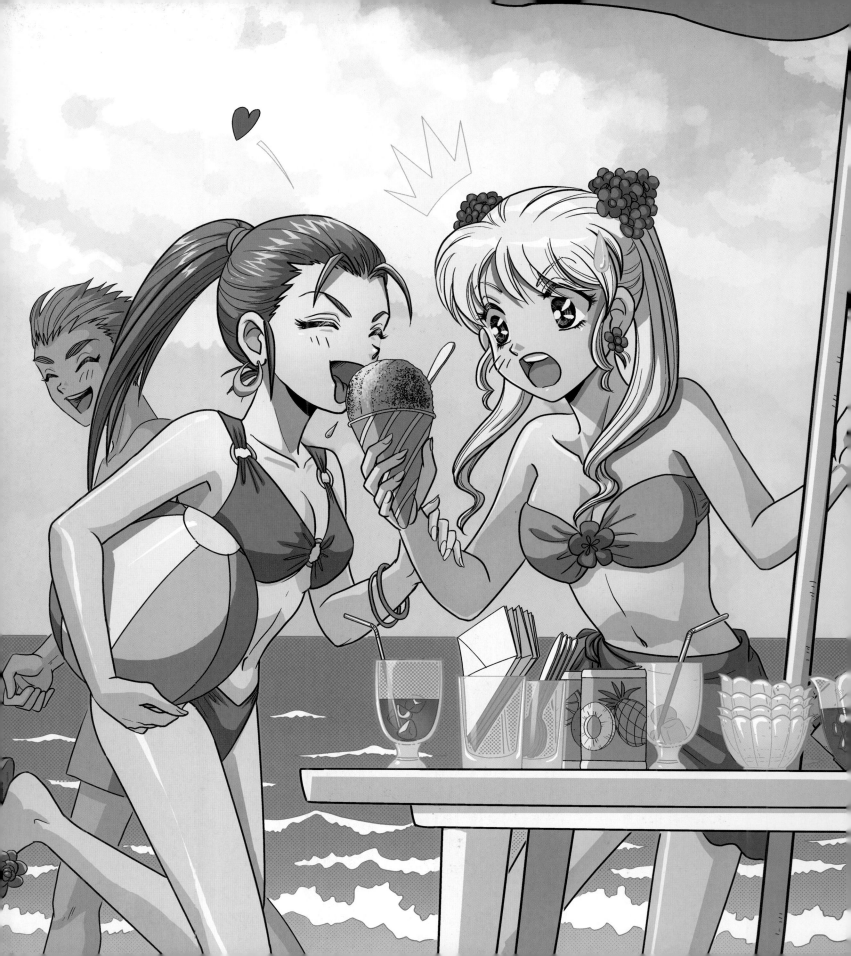

Introduction

When it comes to manga, girls really do rule. Whether they appear in graphic novels and anime, like *Fruits Basket, Love Hina, Sailor Moon, Hana-Kimi, Imadoki!, Real Bout High School,* and *Cardcaptor Sakura,* or *Shojo Beat* magazine, the divas of manga are all the rage. Now you can find all the fabulous females of manga—in one volume of cutting-edge art instruction!

All the coolest, most fascinating types of manga girls are included in these pages. We'll begin with the basics, including drawing the head and body, facial expressions, eye types, figures in action, expressive poses, and female hands and feet. Then we'll move on to a gigantic array of female characters from popular genres, including shojo-style girls, witches, princesses, cat girls, magical girls, fantasy chefs, pretty tomboys, fighter girls, teen vampires and more! Step-by-step demonstrations show you exactly how to recreate these amazing characters.

There are also tons of hints on developing story ideas for your characters, for those of you who may be interested in creating your own graphic novel. So there's plenty of material for you to dig into. This is your ultimate manga reference, one that you can enjoy for years to come. What more could you want?

Drawing Manga Girls: The Basics

In manga, there are as many types of girls as there are stories, and no two manga girls are exactly alike. But there are certain techniques that are used in drawing most girl characters. In this chapter, we'll learn how to draw the manga head, including those fabulous eyes and intense expressions. Then we'll take a look at how to draw the body and put it into some interesting poses. Let's get started!

Drawing the Head

I know it's tempting to dive in and start drawing the features of the face right away. After all, drawing those great eyes and the nose and mouth is the quickest way to see the face come to life. But it's also the fastest way to veer off course.

If we start by drawing the outline of the head and sketching in guidelines to help place the features accurately, when we do add the features, everything will line up correctly. It only takes an extra moment to do it in this order. Try it. What have you got to lose?

Center line bisects nose and mouth

Eyes (and ears!) fit between eye lines

Eye lines

Once you have the foundation in place, you can shade the eyes, fill in the hair and add lots of details– all the fun stuff!

Front View

The front view is the simplest and most straightforward pose to start with. After you draw the basic head shape, add two horizontal eye lines and position the eyes and ears between them. Use a vertical center line to keep everything nice and symmetrical.

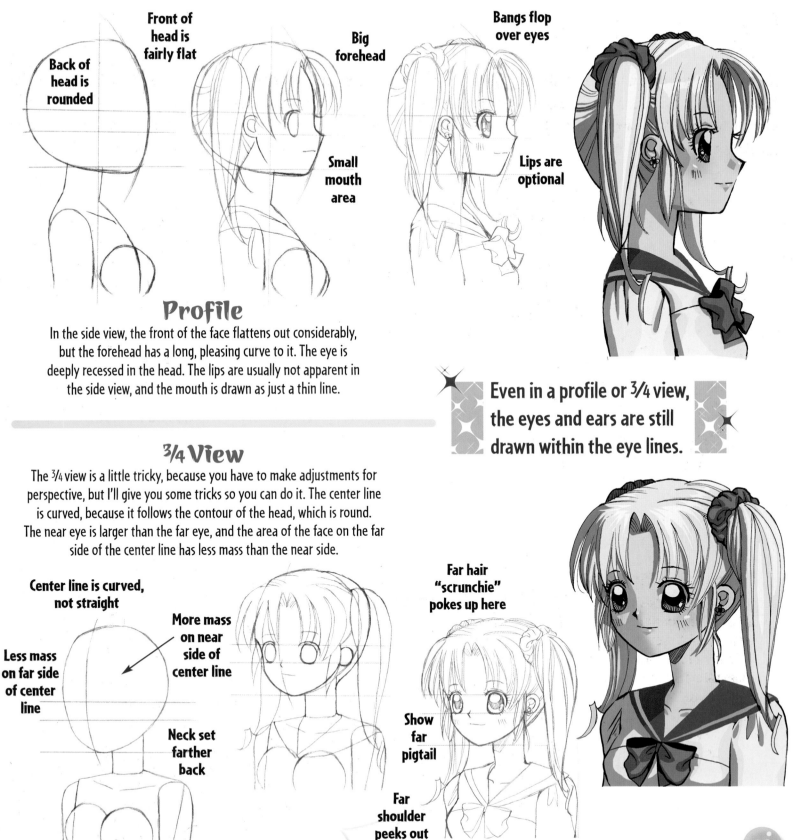

Back of head is rounded

Front of head is fairly flat

Big forehead

Bangs flop over eyes

Small mouth area

Lips are optional

Profile

In the side view, the front of the face flattens out considerably, but the forehead has a long, pleasing curve to it. The eye is deeply recessed in the head. The lips are usually not apparent in the side view, and the mouth is drawn as just a thin line.

Even in a profile or 3/4 view, the eyes and ears are still drawn within the eye lines.

3/4 View

The 3/4 view is a little tricky, because you have to make adjustments for perspective, but I'll give you some tricks so you can do it. The center line is curved, because it follows the contour of the head, which is round. The near eye is larger than the far eye, and the area of the face on the far side of the center line has less mass than the near side.

Center line is curved, not straight

More mass on near side of center line

Less mass on far side of center line

Neck set farther back

Far hair "scrunchie" pokes up here

Show far pigtail

Far shoulder peeks out

It's All About the Eyes

There is no single correct way to draw manga eyes. Here, the same character is drawn with eight different eye styles to show the effect that the eyes have on character design. Everything else stays the same. You can use the styles shown here, which are currently in use in manga around the world, combine them to create a unique eye style, or even invent your own!

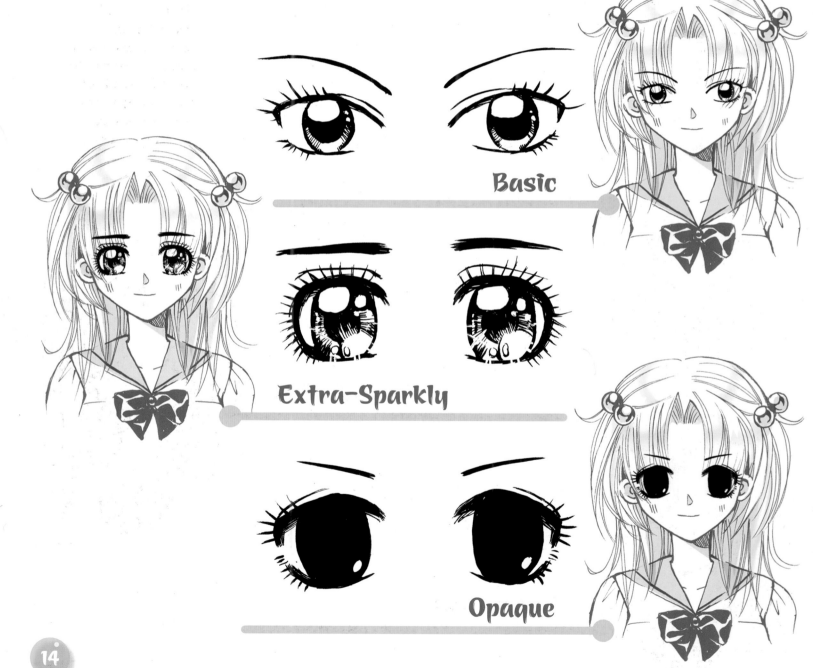

Basic

Extra-Sparkly

Opaque

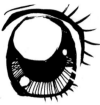

Super-Shiny

Change It Up!

Here are a few details you can change to vary your eye designs:

- The size of the eye "shines"
- The amount of black used for the pupils
- The number of lines in the irises—more lines make the eyes look more brilliant
- The amount of blank area in the eye shines—more equals more glamorous

Sweet

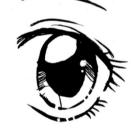

Sentimental

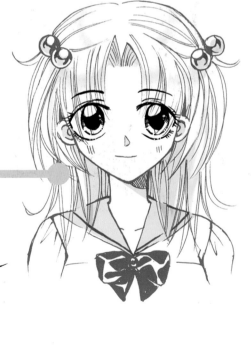

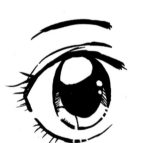

Suspicious

15

Manga Expressions

Special effects make an expression bigger and more intense than it would otherwise be. Be that as it may, special effects are not a necessity in creating a good expression. However, if you want to really punctuate a moment—to drive it home—special effects are the way to go. They visually underline the emotion a character is experiencing and clearly convey it to the reader.

Hint

A few special effects go a long way, so use them sparingly—for example, to end a scene or to make a big point.

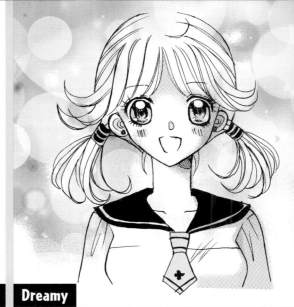

Happy Dreamy

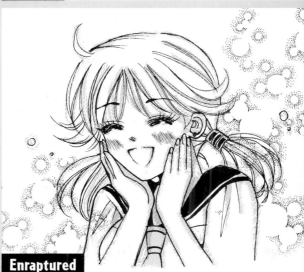

Joyful Enraptured

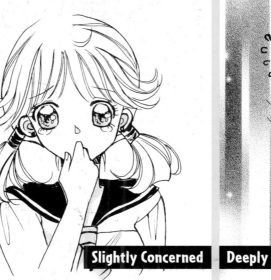

Slightly Concerned

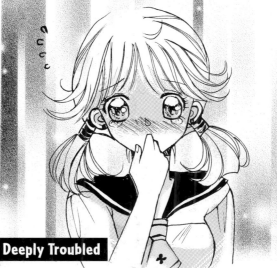

Deeply Troubled

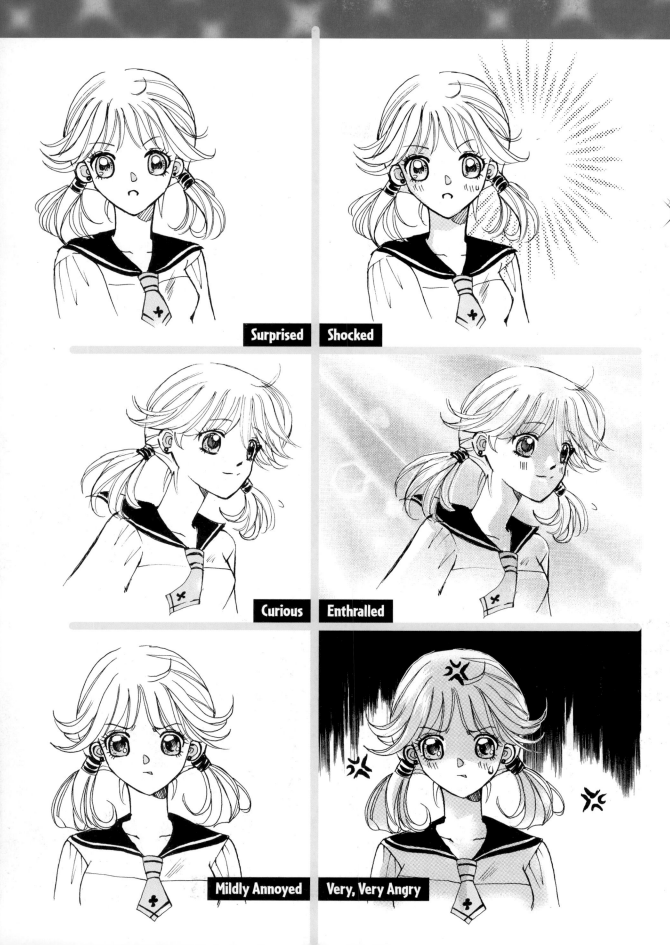

Surprised **Shocked**

Curious **Enthralled**

Mildly Annoyed **Very, Very Angry**

You can create your own special effects using such motifs as flowers, stars, bursts and streaks.

Girls in Glasses

In manga, girls who wear glasses are never dorky. In fact, they're cool and stylish. Glasses are an accessory, just like jewelry. They make a statement. And you can create your own shapes of glasses to suit your character. Just don't skimp on the size of the lenses. Make them too small, and you'll give those gorgeous manga eyes a claustrophobic look.

Hint

When a character is turned in a profile, add lots of space between the lens and the eye. And "disappear" the arm of the glasses that would otherwise obscure the eye.

On some characters, you may choose to have the bangs fall in front of the glasses; on others, they may fall behind, be too short to reach them at all, or be swept to the side.

Drawing the Body

We're going to keep inventing new faces and heads of fabulous females, but now we're also going to draw bodies for them. Posing the same character at different angles is a great way to learn to draw the figure.

Torso Tricks

The torso is easiest to draw when you realize it's drawn in two sections (as in the first sketch at left): the upper half, where the rib cage is, and the lower half, which includes the hips. This technique works no matter what direction the girl is facing or how the torso bends.

Front View

Now let's take a look at the manga girl's figure. The key to drawing the front view is symmetry. Since everything can be seen clearly at this angle (because the entire figure is facing forward), both sides have to line up evenly. That's why it's a good idea to indicate guidelines for the body, as we did with the head. Draw horizontal sketch lines to line up the collarbone, waistline and hips and add a center line down the middle of the figure.

Upper half of torso

Bottom half of torso

Legs start out wide at hips, then taper down toward feet

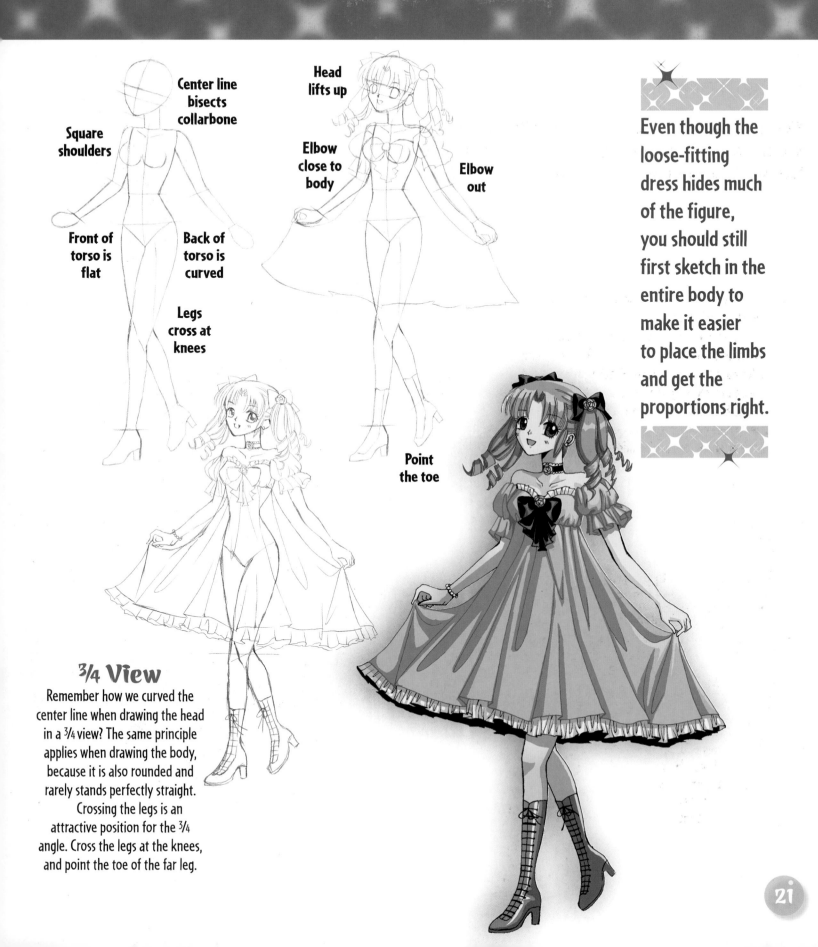

Center line bisects collarbone

Square shoulders

Front of torso is flat

Back of torso is curved

Legs cross at knees

Head lifts up

Elbow close to body

Elbow out

Point the toe

Even though the loose-fitting dress hides much of the figure, you should still first sketch in the entire body to make it easier to place the limbs and get the proportions right.

¾ View

Remember how we curved the center line when drawing the head in a ¾ view? The same principle applies when drawing the body, because it is also rounded and rarely stands perfectly straight. Crossing the legs is an attractive position for the ¾ angle. Cross the legs at the knees, and point the toe of the far leg.

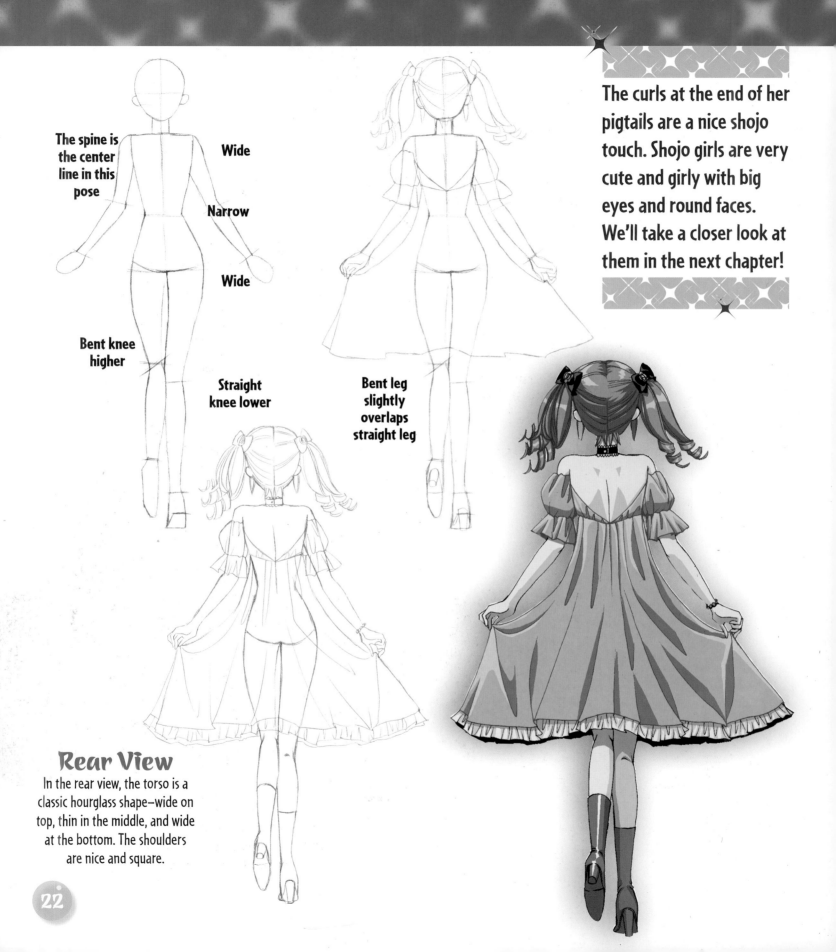

The spine is the center line in this pose

Wide

Narrow

Wide

Bent knee higher

Straight knee lower

Bent leg slightly overlaps straight leg

The curls at the end of her pigtails are a nice shojo touch. Shojo girls are very cute and girly with big eyes and round faces. We'll take a closer look at them in the next chapter!

Rear View

In the rear view, the torso is a classic hourglass shape—wide on top, thin in the middle, and wide at the bottom. The shoulders are nice and square.

Figure Poses

Drawing your character in different poses may be challenging at first, but once you master these poses, drawing the standard ones will be a breeze. You don't have to copy these poses exactly the way you see them here. Experiment and personalize them. That way, you'll not only be learning from this book, but you'll also be developing your creativity.

Square shoulders prop up arms

Toe is pointed and bridge of foot is curved

Line of body is curved, not straight

Seated Pose

Even when seated, ballerinas pose gracefully. Be sure to add width to the bench top so there will be enough surface for her to sit on.

Give Me an M—for Manga!

The cheerleader is the classic top-of-the-pack girl. She's the girl who gets the star athlete as a boyfriend. She's also often a gossip—who gets her due at the end of the story. Let's take a look at a classic cheerleading pose.

Arm at right angle and raised over head

Hand on hip

Tuck lower leg under knee

Heel off ground as she pushes off with this foot

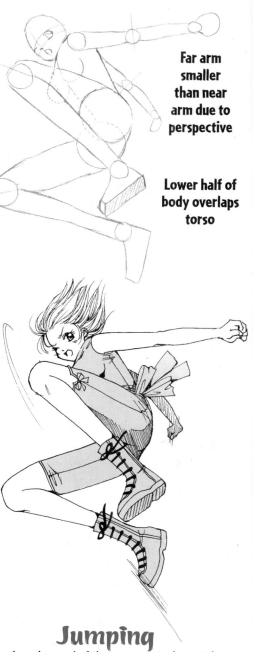

Far arm smaller than near arm due to perspective

Lower half of body overlaps torso

Jumping

At the other end of the spectrum is the social rebel, the school outcast, who hangs with the other outcasts or the runaways. She's the only one the cheerleader is afraid of. She can actually outdo all of the cheerleader's moves—without one bit of formal training.

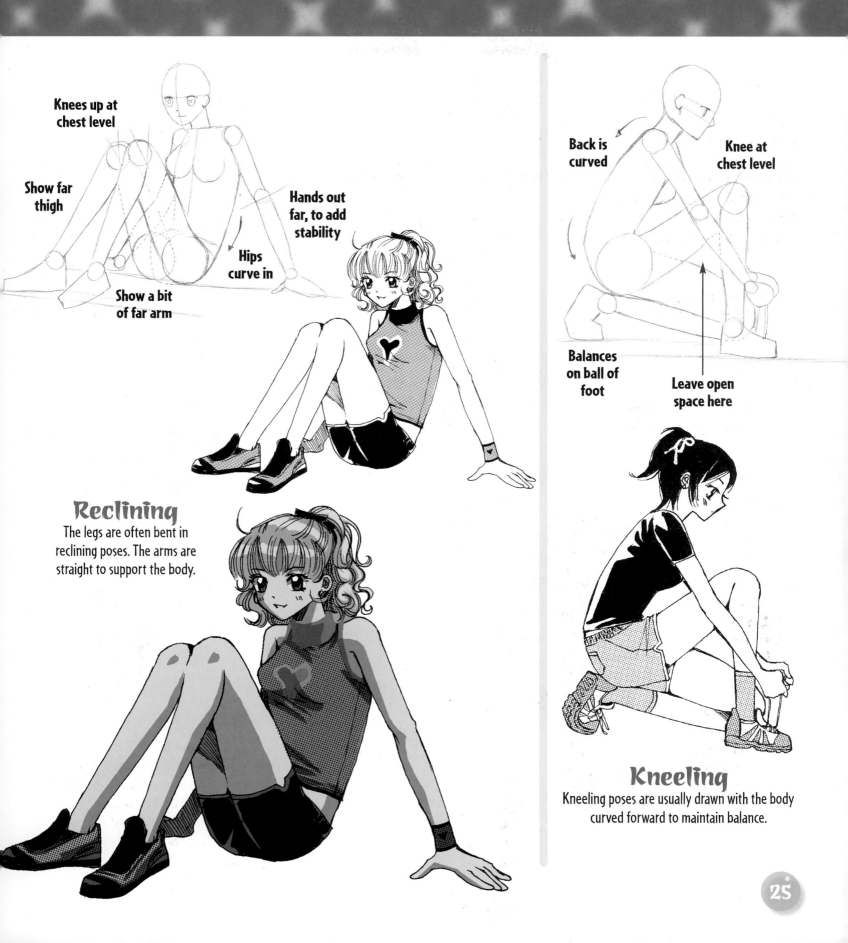

Knees up at chest level

Show far thigh

Hands out far, to add stability

Hips curve in

Show a bit of far arm

Reclining
The legs are often bent in reclining poses. The arms are straight to support the body.

Back is curved

Knee at chest level

Balances on ball of foot

Leave open space here

Kneeling
Kneeling poses are usually drawn with the body curved forward to maintain balance.

Drawing Hands and Feet

Now that we have the basics of drawing the head and body covered, let's zoom in and take a look at the hands and feet. Many artists find drawing hands and feet difficult, but with a few tips and tricks, you'll get a "hand"-le on them in no time! (Sorry, I couldn't resist.)

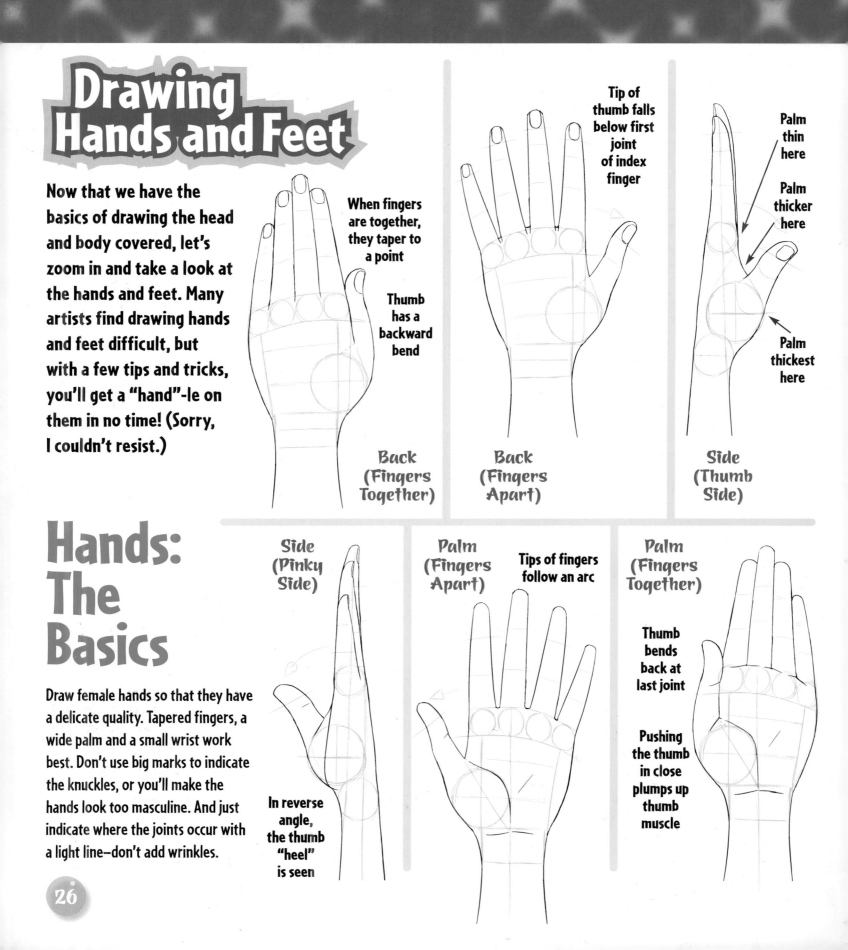

When fingers are together, they taper to a point

Thumb has a backward bend

Back (Fingers Together)

Tip of thumb falls below first joint of index finger

Back (Fingers Apart)

Palm thin here

Palm thicker here

Palm thickest here

Side (Thumb Side)

Hands: The Basics

Draw female hands so that they have a delicate quality. Tapered fingers, a wide palm and a small wrist work best. Don't use big marks to indicate the knuckles, or you'll make the hands look too masculine. And just indicate where the joints occur with a light line—don't add wrinkles.

Side (Pinky Side)

In reverse angle, the thumb "heel" is seen

Palm (Fingers Apart)

Tips of fingers follow an arc

Palm (Fingers Together)

Thumb bends back at last joint

Pushing the thumb in close plumps up thumb muscle

26

Hand Gestures

The hands are very flexible. Even straight fingers aren't always perfectly straight, but can curve backward when pointing. Try to vary the finger placement for variety; don't draw them all in a perfect row. That would be too boring for manga!

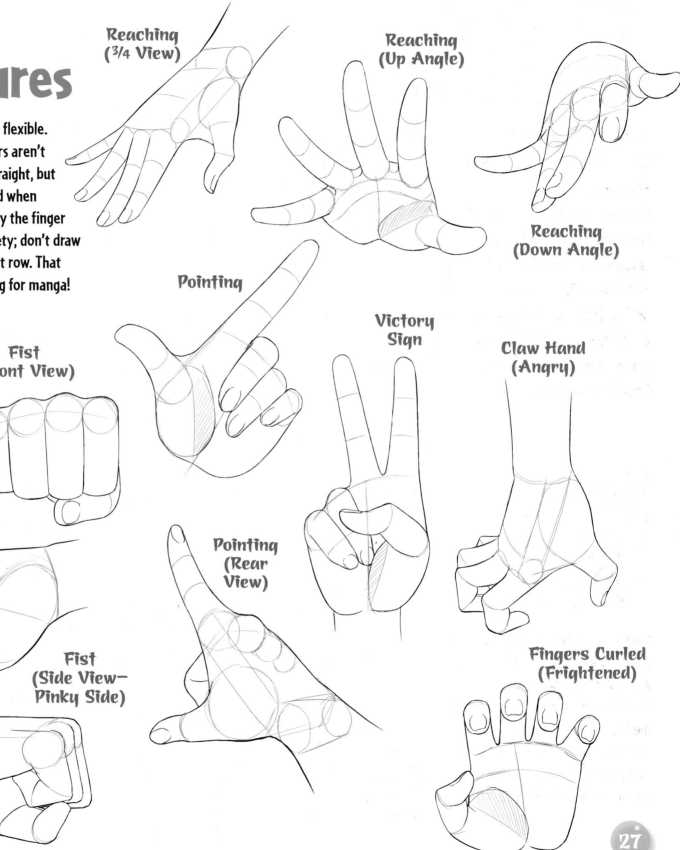

Reaching (3/4 View)

Reaching (Up Angle)

Reaching (Down Angle)

Pointing

Fist (Front View)

Victory Sign

Claw Hand (Angry)

Fist (Side View— Thumb Side)

Pointing (Rear View)

Fist (Side View— Pinky Side)

Fingers Curled (Frightened)

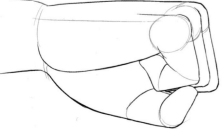

Feet: The Basics

These are all the basic positions you'll ever need to know in order to draw the foot. Unlike the hand, the foot is not an expressive part of the body. We're more concerned with just making it look right. And to do that, there are a few specific areas of the foot we need to identify and be sure to include in our drawings. Some of these areas are apparent only at certain angles.

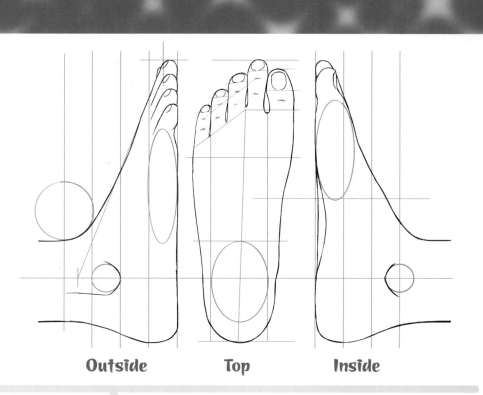

Outside **Top** **Inside**

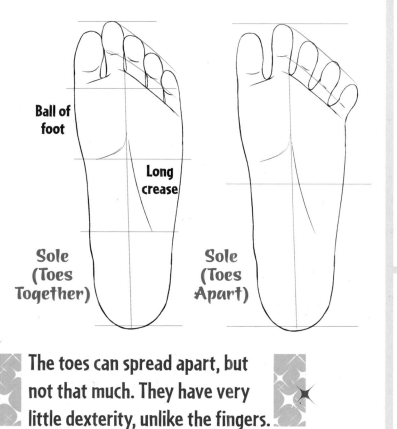

Ball of foot

Long crease

Sole (Toes Together) **Sole (Toes Apart)**

The toes can spread apart, but not that much. They have very little dexterity, unlike the fingers.

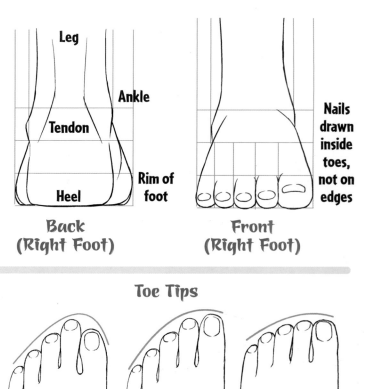

Leg

Ankle

Tendon

Rim of foot

Heel

Back (Right Foot)

Nails drawn inside toes, not on edges

Front (Right Foot)

Toe Tips

Middle toe longest **Toes on a diagonal** **Even across**

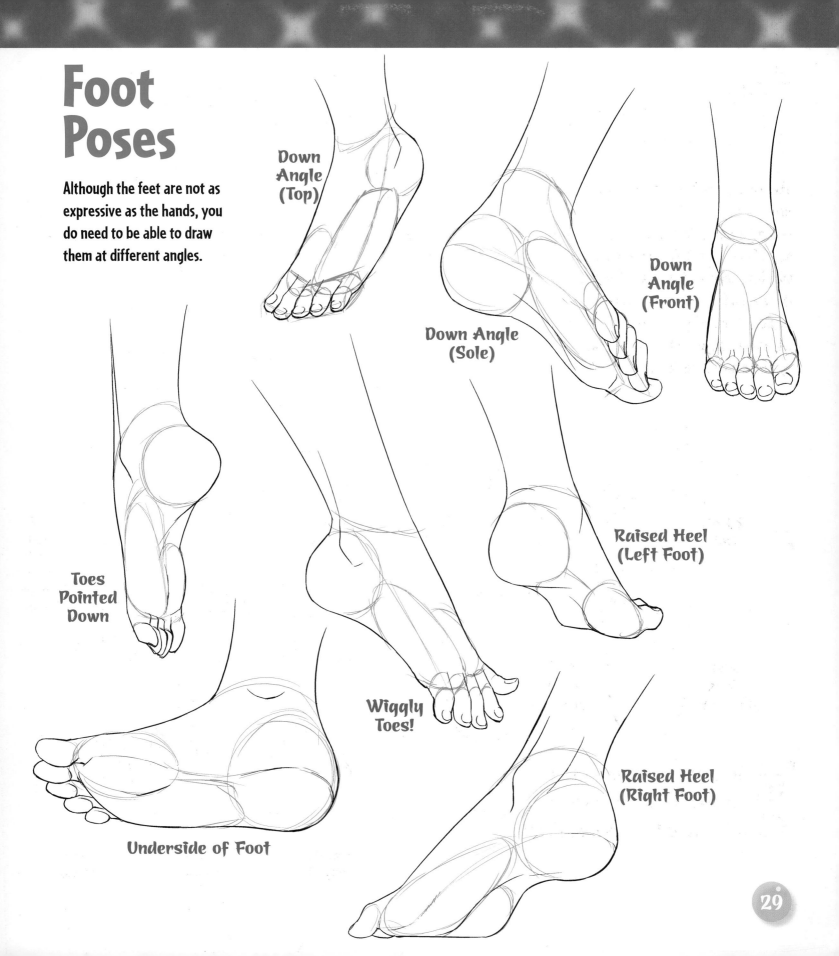

Foot Poses

Although the feet are not as expressive as the hands, you do need to be able to draw them at different angles.

Down Angle (Top)

Down Angle (Sole)

Down Angle (Front)

Raised Heel (Left Foot)

Toes Pointed Down

Wiggly Toes!

Underside of Foot

Raised Heel (Right Foot)

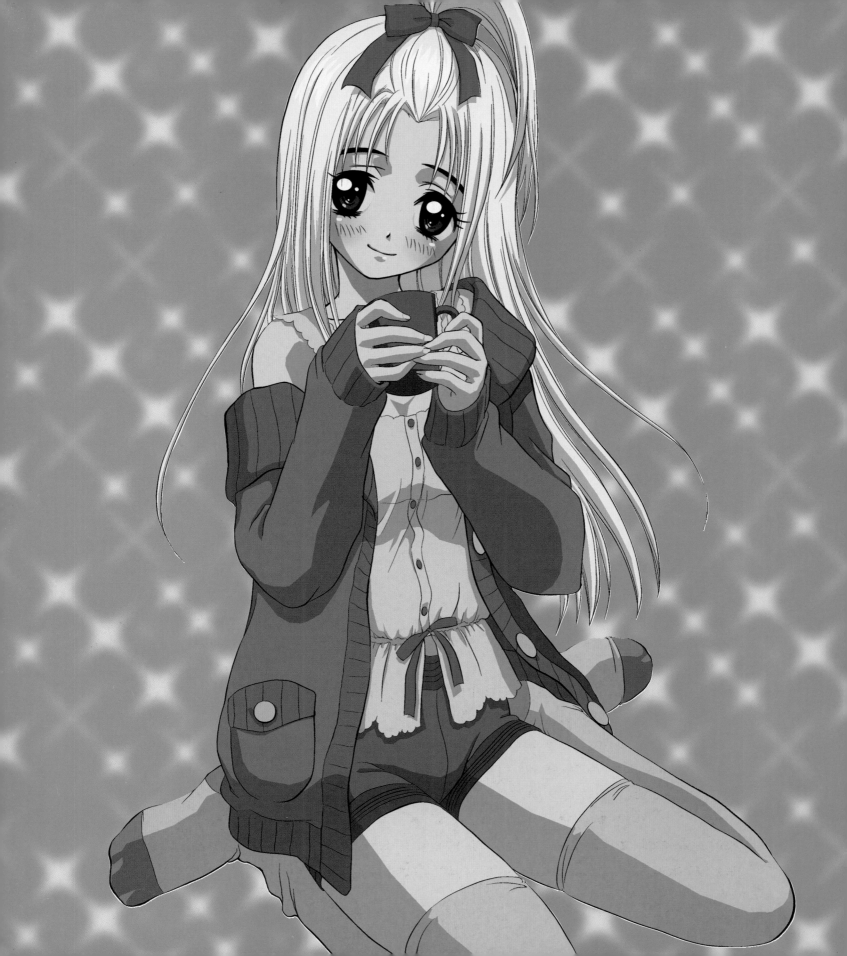

Shojo Style!

The classic character in the shojo style is the perky, cute, innocent girl. Shojo girls have a dreamy look, with round faces and large, glistening eyes. Shojo gals are known to get emotional, and they wear their feelings on their sleeves. That's because they're usually embroiled in some sort of drama. And our shojo girl may weigh only 99 pounds, but she's got guts and won't back down when she believes in something—or someone.

Shojo Expressions

Famous for their expressive faces, shojo characters react visibly to many situations. And even when they try to hold their feelings inside, we can usually tell what they're thinking!

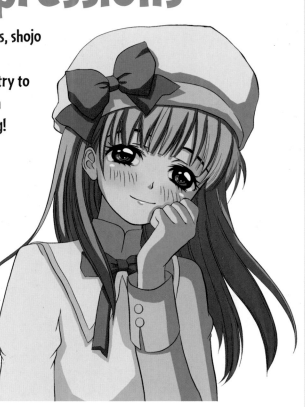

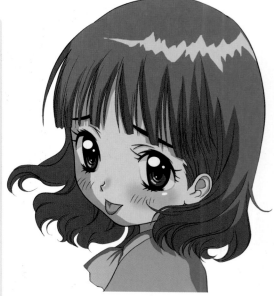

Isn't He Wonderful?
Half-closed eyes combined with a small smile create a dreamy expression.

Did He Notice Me?
A typical playful manga expression. She has a tiny smile with her tongue poking out halfway—not all the way. The eyebrows curve up in a hopeful expression.

I Hope Her Hair Falls Out!
The eyebrows curve up but press down on the eyes at the same time. Her small mouth curves down into a "hmmph!" position.

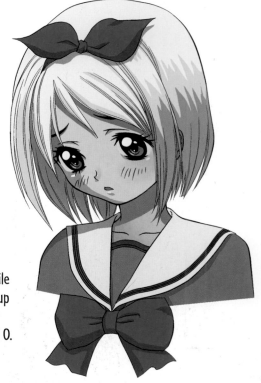

Maybe He Loves... Her!
She looks down, while her eyebrows push up and together. Her mouth forms a small O.

Will He Call?

This nervous expression is created by drawing the mouth slightly open and the eyes glancing off to one side.

I Forgot My Own Phone Number!

Don't even try to reason with this one—at least not while she's in her silly spell. Her eyes are closed and her tongue sticks out.

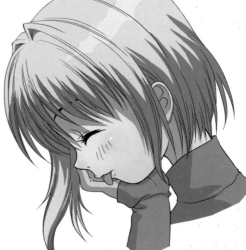

Yes, I Like Movies!

The eyes curve down when a person smiles widely. Keep the mouth small, or it will look as if she is laughing.

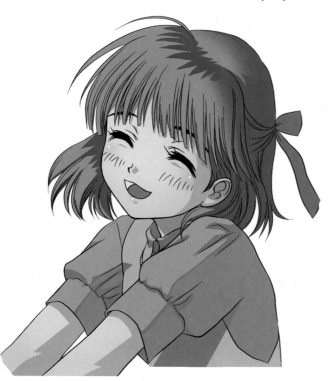

Maybe I Shouldn't Have Sent Him That Text...

A pouty lower lip, big, glistening eyes and blush marks on her cheek—you can't get more expressive than that!

33

Classic Shojo Outfit

The sailor collar and trim around the sleeves and bottom of the dress are dead giveaways that this is the traditional Japanese "sailor suit"–the uniform worn by lots of school-age shojo characters. It makes them look cute and bubbly–perfect for this style of manga. Knee socks and a large ribbon in the hair give her a youthful appearance.

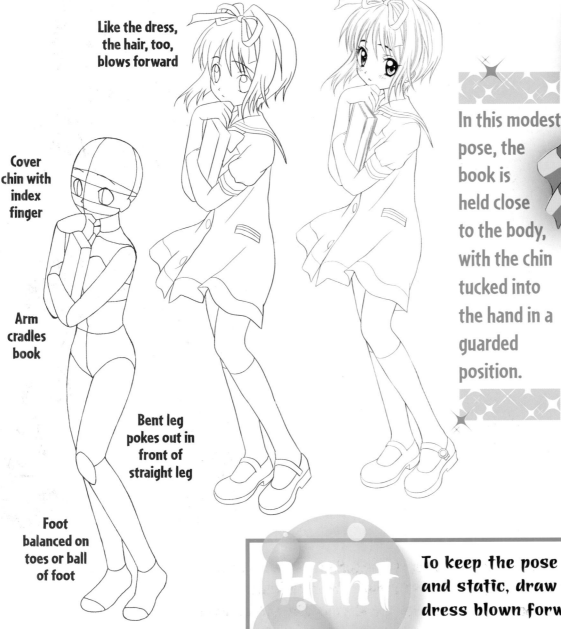

Like the dress, the hair, too, blows forward

Cover chin with index finger

Arm cradles book

Bent leg pokes out in front of straight leg

Foot balanced on toes or ball of foot

In this modest pose, the book is held close to the body, with the chin tucked into the hand in a guarded position.

Hint To keep the pose from looking stiff and static, draw the hair and the dress blown forward by the wind.

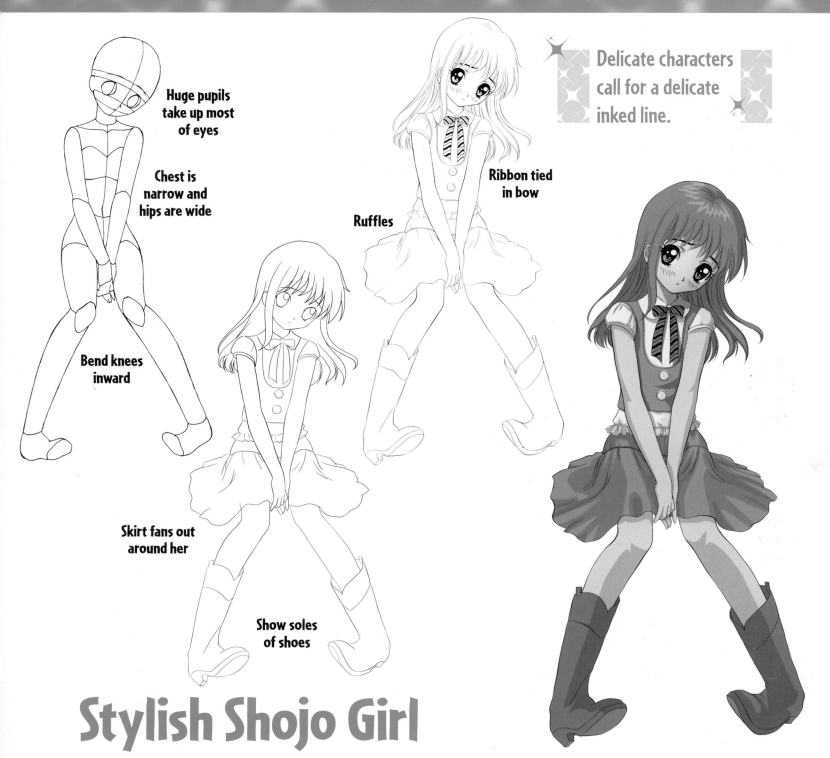

Huge pupils take up most of eyes

Chest is narrow and hips are wide

Bend knees inward

Skirt fans out around her

Show soles of shoes

Ruffles

Ribbon tied in bow

Delicate characters call for a delicate inked line.

Stylish Shojo Girl

This fashionable outfit looks like a Japanese school uniform that's been specially modified—with boots, a bow and ruffles. Even some school uniforms now show a degree of individuality in modern manga. The little tilt to the head, the hands demurely placed on her skirt, and the curled feet create a cute and innocent look.

More Shojo Girls!

Here are a variety of girls for you to practice drawing. These are the ebullient types of shojo girls that you want to bring into your own manga drawings and, eventually, into your own graphic novels. Shojo girls are typically self-composed, but at the same time vulnerable and sweet.

Standing in the Wind

This is a perfect summer outfit for walking along the boardwalk. She might "accidentally" let go of the hat when her crush walks by. Then he'll have to chase it down for her, and she can act ever so grateful!

Her hat, hair, dress and ribbons on the hat and dress all blow back in the wind.

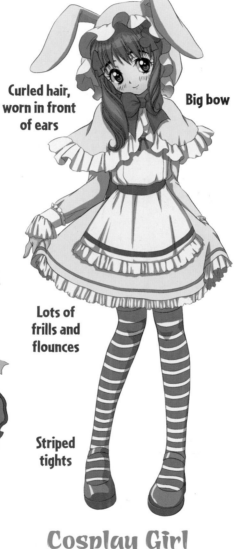

Curled hair, worn in front of ears

Big bow

Lots of frills and flounces

Striped tights

Cosplay Girl

"Cosplay" is short for "costume play." Devotees of manga and anime dress up like their favorite characters and attend manga and anime conventions. The costumes range from sweet shojo schoolgirls to fantasy fighters. This shojo cosplayer wears a frilly rabbit outfit.

Sipping Coffee and Steamed Milk

Time for a coffee break! Her clothing is all soft and oversized, as if she had wrapped herself in a cozy old sweater and curled up in front of a fire. Note the relaxed sitting position. The sweater falls off her shoulders as she cups the mug with two hands, savoring the moment.

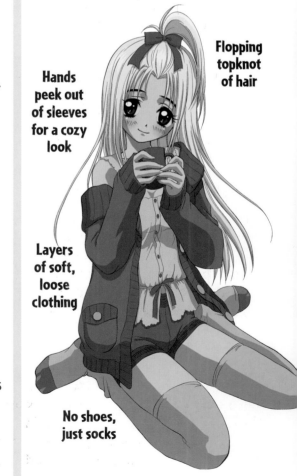

Flopping topknot of hair

Hands peek out of sleeves for a cozy look

Layers of soft, loose clothing

No shoes, just socks

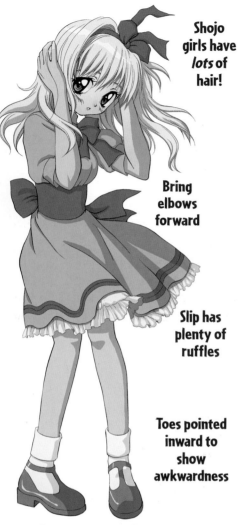

Shojo girls have *lots* of hair!

Bring elbows forward

Slip has plenty of ruffles

Toes pointed inward to show awkwardness

Oh No—My Hair!

Two hours at the salon and a single gust of wind threatens to undo the entire thing. Draw her holding her hair in place as it blows wildly in the wind. The wind also blows her ribbon, sash and dress. Her knees knock together as she buckles under the force of the breeze.

Urban Teen

She's more streetwise than a suburban daddy's girl who rarely ventures into the city. While the daddy's girl wears her mother's designer shoes, the city teen wears funky boots she bought at a vintage store.

Form-fitting top

Short skirt

High leggings

Cute clunkers

Beautiful, long, flowing hair

Figure bends forward at waist

Hands hold feet near ankles

Point the toes for a feminine look

Nighttime Musings

In manga, characters feel just what every teen feels: the angst and growing pains of trying to fit in. Will things work out for them? What will their future hold? These introspective moments in a story communicate the character's fears and frustrations to the reader.

Story Time

When you're writing a story about a group of friends, it's easy to lose track of one or more of them and concentrate mainly on your favorite character(s). But what you may not realize is that your reader may have a different favorite—one that you might have ignored. So be sure to keep all of the characters involved throughout the story.

Magical Girls

Magical girls are extremely popular shojo characters. They are regular schoolgirls who can transform into super-glamorous versions of themselves. Their magical costumes are all tricked out with bells and whistles. Many of the magical girls have wands and fantasy pets—strange little plump creatures from other universes with whom they pal around.

Finger points playfully

Hand hides most of arm in foreshortened pose

Deep angle in small of back

Baubles in hair

Big shines in big eyes

Fighting Magical Girl

This magical girl has to manage having two identities—one as a typical schoolgirl and a secret one as a glamorous intergalactic heroine who travels between universes to save the earth from evil invaders. Her parents and everyone but her best friends are unaware of her secret identity.

The magical fighter girl always wears boots

Foreshortening

Foreshortening is a drawing technique in which objects that are coming toward you are compressed and enlarged to create depth in the image. See how the hand holding the wand is much larger than the other? That's foreshortening!

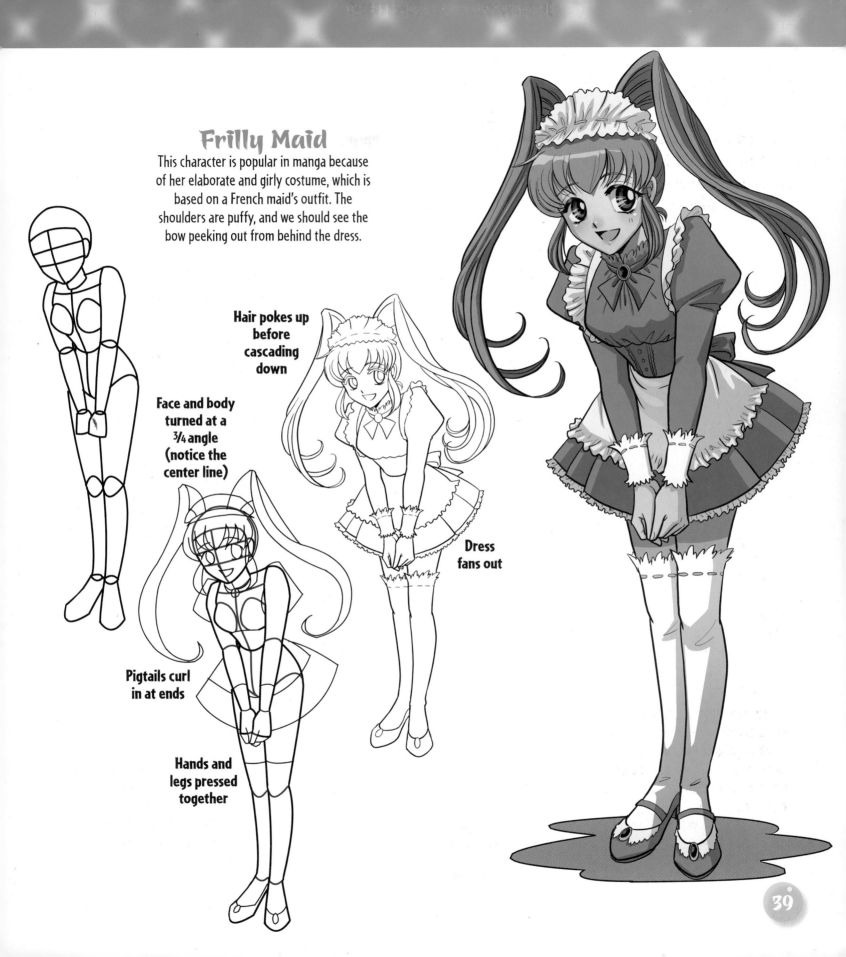

Frilly Maid

This character is popular in manga because of her elaborate and girly costume, which is based on a French maid's outfit. The shoulders are puffy, and we should see the bow peeking out from behind the dress.

Hair pokes up before cascading down

Face and body turned at a ¾ angle (notice the center line)

Pigtails curl in at ends

Hands and legs pressed together

Dress fans out

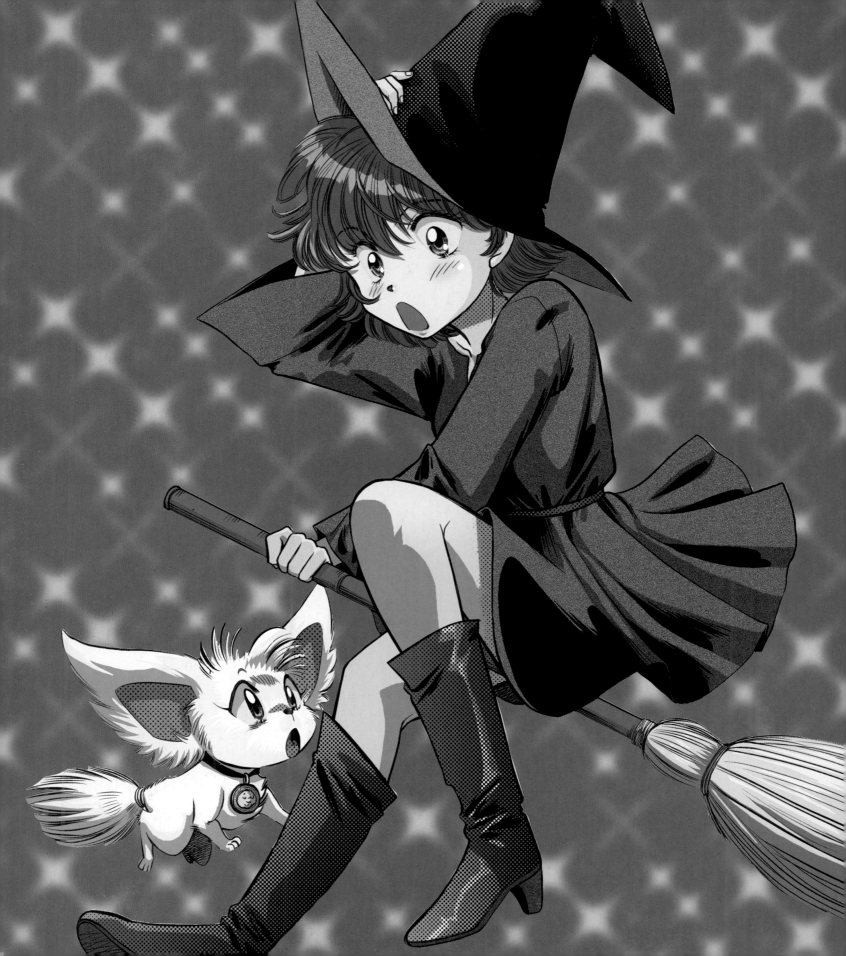

Witches, Vampires and Cat Girls

These curiously cute characters show up in a host of popular manga graphic novels. Witches run the gamut from spooky to pretty to chibi and impossibly cute. Like girl witches, teen vampires can also be cute and perky. However, they can also be fierce, gothic and malevolent. Part cat, part costume, cat girls are pretty, playful and very popular characters.

Girl Witches

Witches really stand out. Besides their irresistible character designs, they wear striking costumes that pop off the page. And you don't have to slow down the plot to explain how your character got her power. The audience just accepts it, because she's a witch!

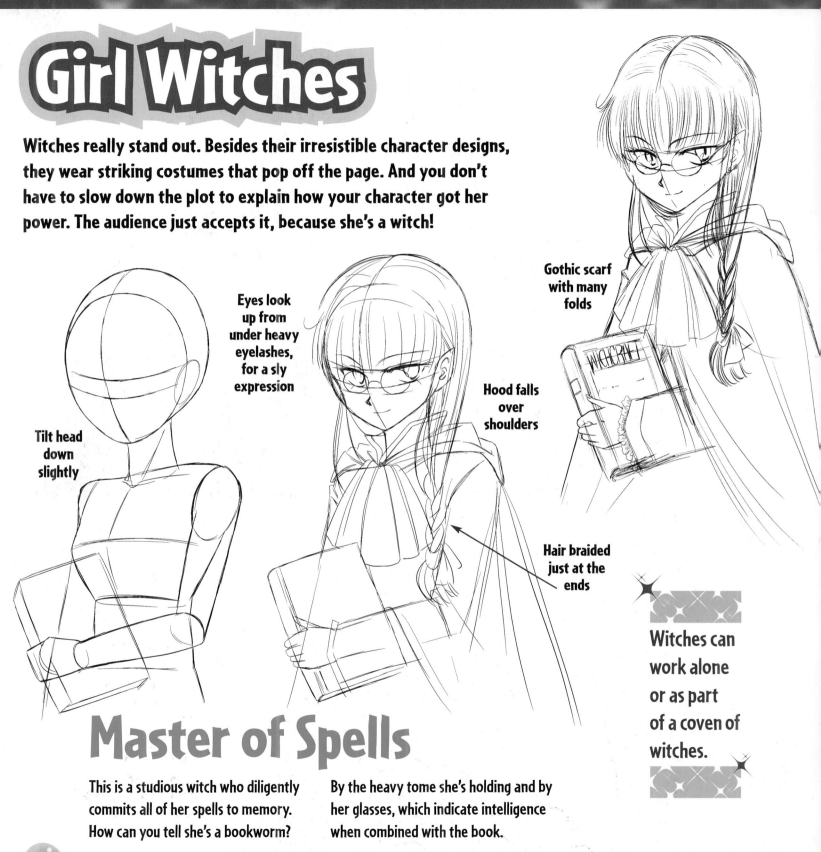

Tilt head down slightly

Eyes look up from under heavy eyelashes, for a sly expression

Gothic scarf with many folds

Hood falls over shoulders

Hair braided just at the ends

Witches can work alone or as part of a coven of witches.

Master of Spells

This is a studious witch who diligently commits all of her spells to memory. How can you tell she's a bookworm?

By the heavy tome she's holding and by her glasses, which indicate intelligence when combined with the book.

Witchy Wardrobes

There are four must-haves for your witch's costume:

- WITCH'S HAT
- CAPE
- BOOTS
- MAGICAL PROP
(a broom, a thick book on witchcraft, a crystal ball, or even a black cat)

First-Time Flyer

Afraid of flying? So is she! She can't even find the turn signal on this broom. And forget about parallel parking. Not all witches are good at "witching." She's only just grown into her magical powers, and she's having a difficult time learning to direct them.

Hold on tight to that hat!

Slanted broomstick shows instability

Doggy is all head, with very little body

Legs in chaotic position

By facing in the opposite direction of his mistress, the pup appears to be saying, "No, no! Wrong way!!"

Big eyes and even bigger ears!!

Indicate several folds of the skirt

Show dimension at end of broom

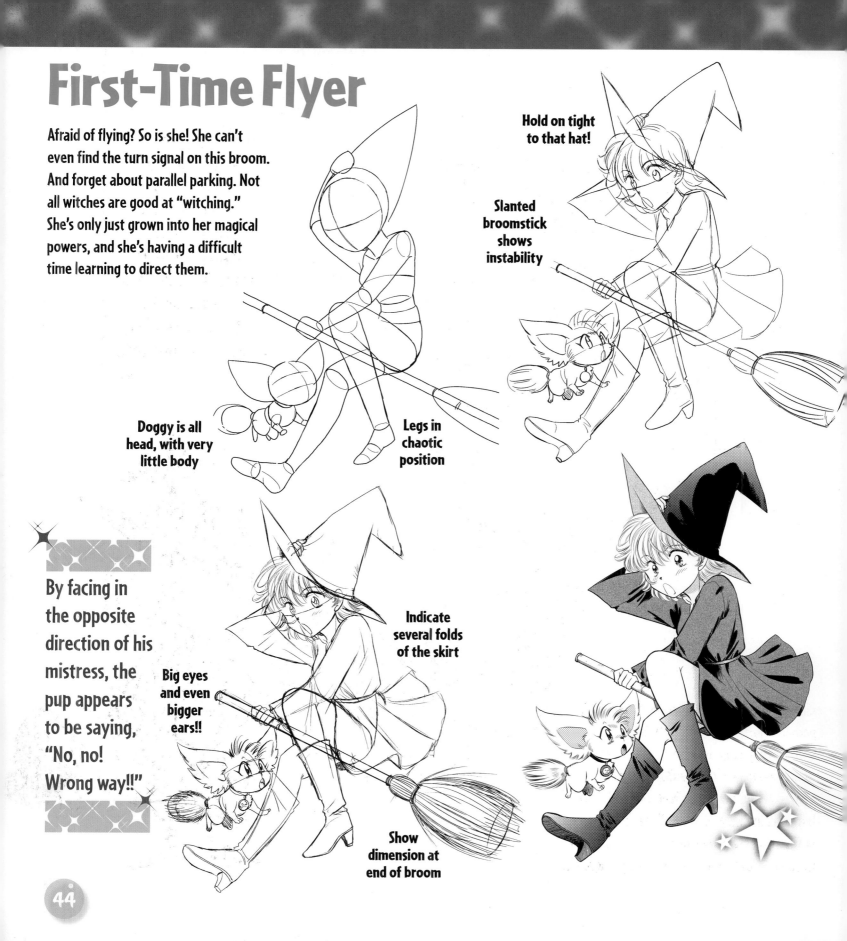

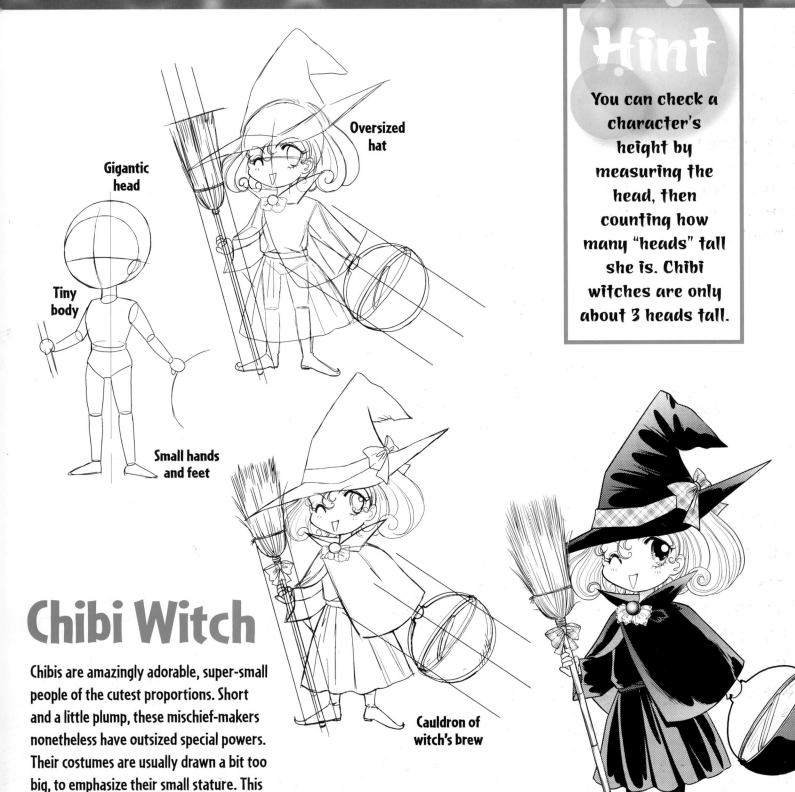

Gigantic head

Tiny body

Small hands and feet

Oversized hat

Hint

You can check a character's height by measuring the head, then counting how many "heads" tall she is. Chibi witches are only about 3 heads tall.

Chibi Witch

Chibis are amazingly adorable, super-small people of the cutest proportions. Short and a little plump, these mischief-makers nonetheless have outsized special powers. Their costumes are usually drawn a bit too big, to emphasize their small stature. This petite witch has tiny hands and feet—and no nose at all! But chibi eyes are always gigantic.

Cauldron of witch's brew

Teen Vampires

These creatures of the night may look pretty, but they harbor evil intent: to sink their teeth into your neck—their version of fast food. They're often drawn with pointed ears and fangs, although you need only show the fangs when an attack is imminent. Bat-like wings are a good look for vampires, but vampires don't walk around with their wings in plain view. Remember, they have to pass themselves off as human. Once the humans have let down their guard, the vampire can strike.

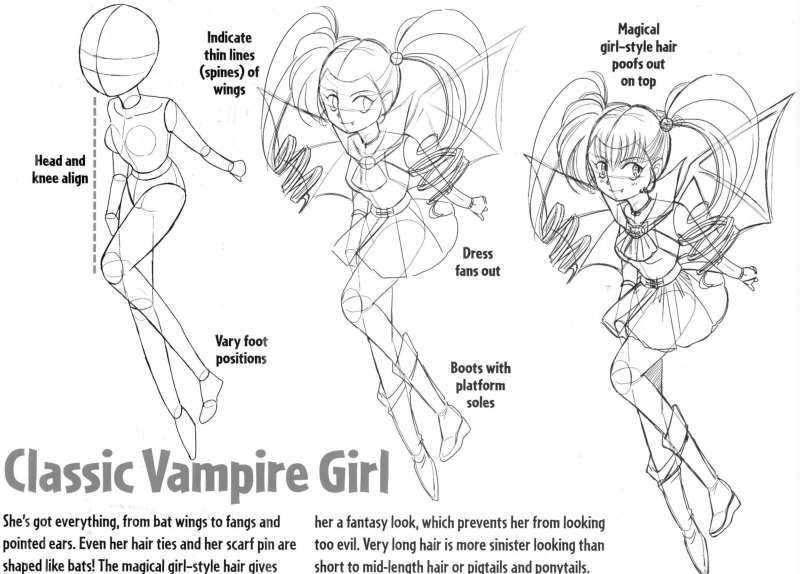

Head and knee align

Indicate thin lines (spines) of wings

Vary foot positions

Dress fans out

Boots with platform soles

Magical girl-style hair poofs out on top

Classic Vampire Girl

She's got everything, from bat wings to fangs and pointed ears. Even her hair ties and her scarf pin are shaped like bats! The magical girl-style hair gives her a fantasy look, which prevents her from looking too evil. Very long hair is more sinister looking than short to mid-length hair or pigtails and ponytails.

Don't make her pointed ears too big, or she'll look like a dark faerie instead of a vampire.

Schoolgirl Vampire

No one at school wants to be her friend just because she's a vampire. Even her best friends abandon her. What about her boyfriend? What will he say? You, as the story creator, have some decisions to make: Does her boyfriend fight for her or run like a coward? Or is he secretly a vampire, too?

With the school uniform, simple hairdo and big, teary eyes, we're playing up the human aspect of the girl and trying for sympathy.

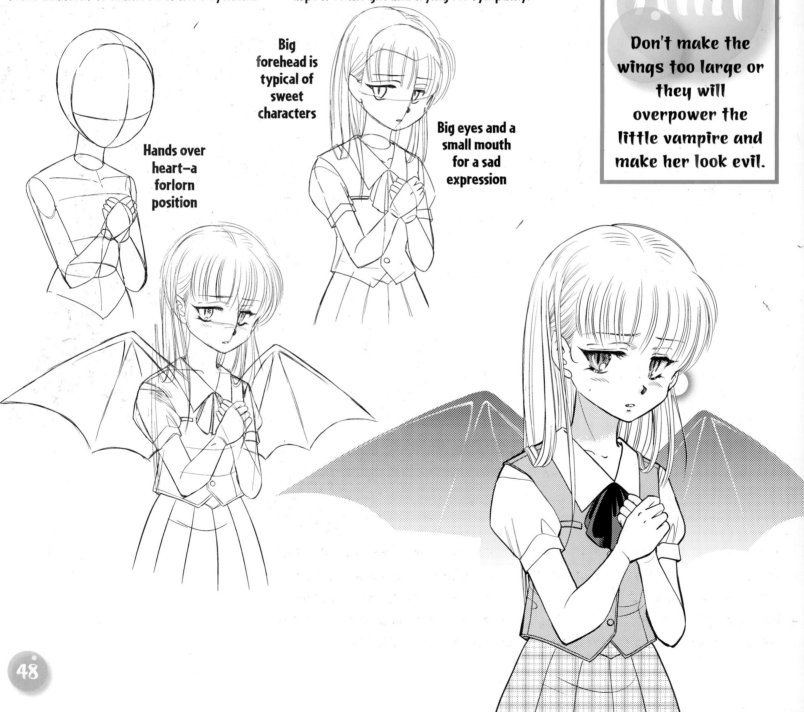

Hands over heart—a forlorn position

Big forehead is typical of sweet characters

Big eyes and a small mouth for a sad expression

Hint

Don't make the wings too large or they will overpower the little vampire and make her look evil.

48

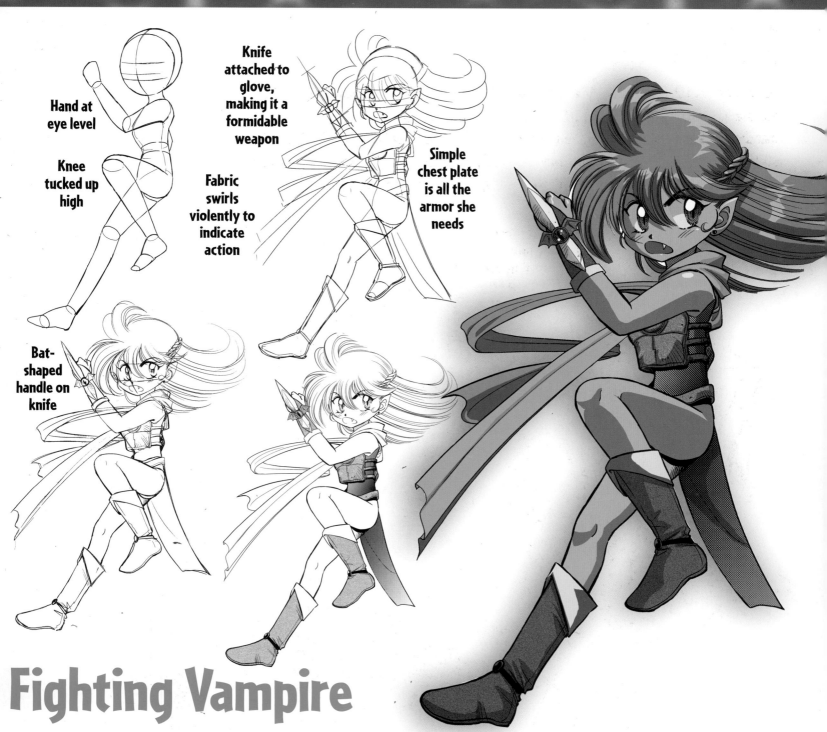

Hand at eye level

Knee tucked up high

Knife attached to glove, making it a formidable weapon

Fabric swirls violently to indicate action

Simple chest plate is all the armor she needs

Bat-shaped handle on knife

Fighting Vampire

She may be small, but she packs a big bite. With just a hint of armor and weaponry, you can turn an ordinary vampire into a fantasy fighting vampire. The sleeveless and legless bodysuit she wears is typical of the fantasy fighter genre. But unlike the usual fantasy fighter, who has long legs and sports a graceful, heroic stance, the vampire girl fighter is shorter and cuter—sort of a cross between a chibi and a fighter.

Cat Girls—Meow!

Cat girls are a popular subset of the shojo genre. They're playful and kittenish. They sometimes wear cat costumes, while at other times they have actual cat ears, tails and claws. Some of the best ones, like those shown here, combine the two approaches: a cat costume with some organic cat features.

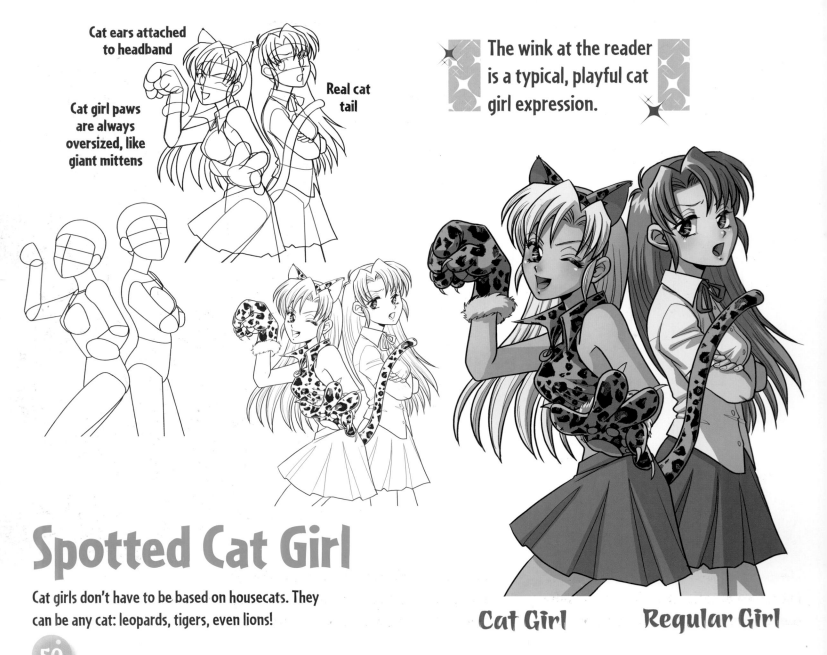

Cat ears attached to headband

Cat girl paws are always oversized, like giant mittens

Real cat tail

The wink at the reader is a typical, playful cat girl expression.

Spotted Cat Girl

Cat girls don't have to be based on housecats. They can be any cat: leopards, tigers, even lions!

Cat Girl Regular Girl

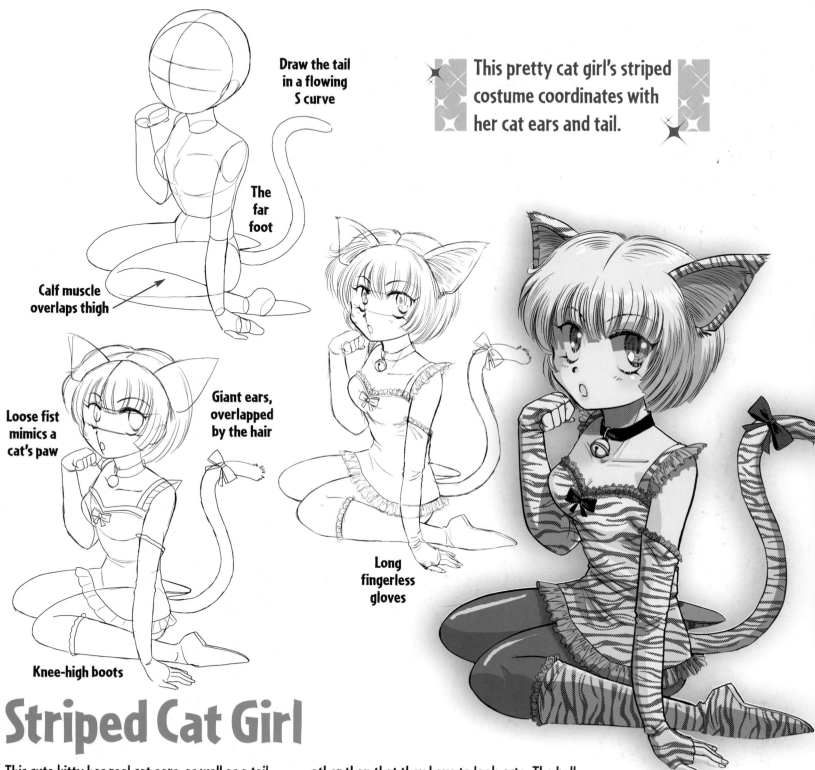

Draw the tail in a flowing S curve

The far foot

Calf muscle overlaps thigh

This pretty cat girl's striped costume coordinates with her cat ears and tail.

Loose fist mimics a cat's paw

Giant ears, overlapped by the hair

Long fingerless gloves

Knee-high boots

Striped Cat Girl

This cute kitty has real cat ears, as well as a tail, but the rest of her is human. You can go with any combo in creating cat girls. There are no rules,

other than that they have to look cute. The bell hanging from her collar and one hand curled up like a paw are both reminiscent of a true cat.

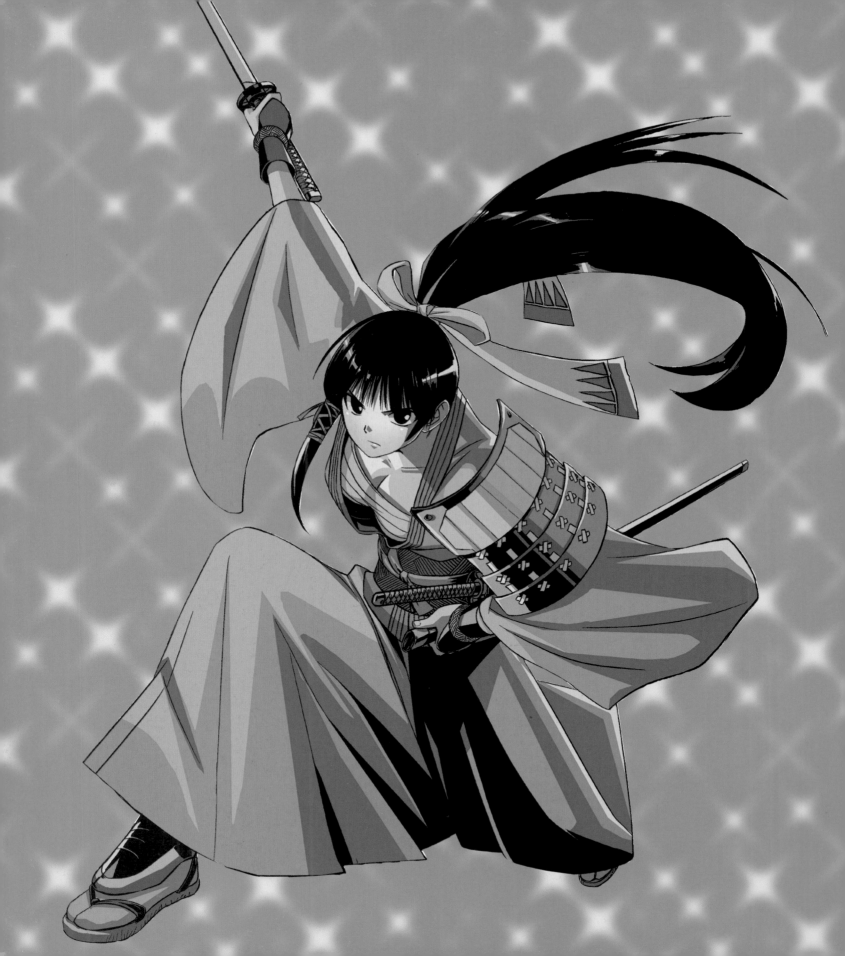

Adventure Girls

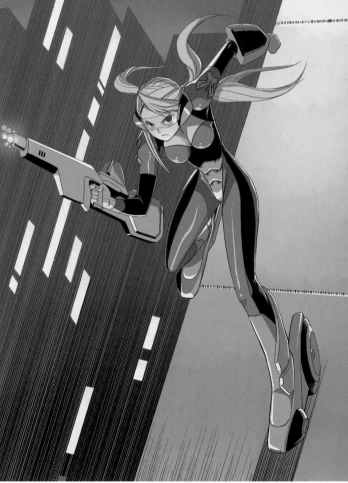

Now we move on to adventure characters—the ones who appear in all sorts of action manga. These fearless fighters run the gamut from primitive gals of the jungle to sci-fi fighters to dark angels. Some use their fighting skills on the side of justice and all that is right and good, while others have more nefarious motives. Whether battling beasts or swordfighting evil samurai, they give the guys in manga a run for their money.

Girl of the Jungle

Lots of manga adventure stories feature brave fighter girls. This girl is an expert with primitive weapons. With that boomerang, she can take on any adversary. She also has a special ability to communicate with animals. She can hear their thoughts, and they understand hers.

Far leg wraps around body of animal

Back arches

Line of back is curved, not straight

Ears are positioned at 45-degree angles

Head hangs low

Back legs look extra-small due to perspective

Bent paw shows motion

The Quest

Hey, what's that star on the cat's forehead all about? It's a sign that this is an enchanted creature, most likely a human who has been cursed and must complete a specific quest to reverse the curse. The girl would know his true identity, and she's the only one who can help him. Together they go on adventures, such as hunting for the warlock who first put the curse on him.

Beast Slayer

This gal doesn't need a guy to walk her home at night in order to feel safe. In fact, beasts need someone to walk them home in case they run into her! Her weapon of choice is a flamethrower with a multidirectional stream. She used to hate hearing the screams of those ugly, flying things when the flames would fry 'em. Did she stop hunting them? Nah. She got some earplugs.

Flames bounce off monster and go in all directions

Don't let creature and girl overlap

Hint

Notice how the bad guys are evenly spaced out across the image, but for variety, each one is placed at a different distance from the slayer.

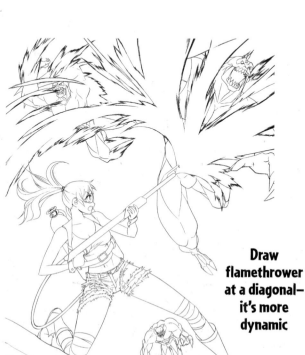

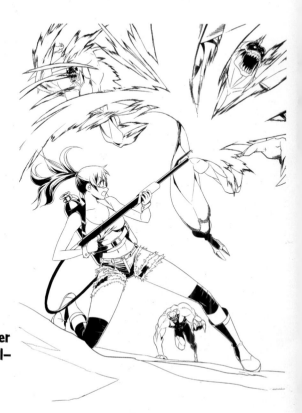

Draw flamethrower at a diagonal—it's more dynamic

Action Lines

The action lines streaking into the distance do more than add a sense of movement to the scene. They bring darkness to the picture, which makes the light-colored flames stand out. Without the contrast, the flames would get lost in the image. Instead, they really pop off the page and look searing hot.

Sci-Fi Spy

Sci-fi characters usually wear formfitting bodysuits, often with stripes running down the sides for a sharp look. This gal sports turbo rollerblades. With them, she can roll up and down the sides of any building. This action pose is actually a simple walking pose, but with more arm movement. And, as in a walking pose, the arms and leg move in opposite directions. In other words, the right arm is back while the left leg is in front, and vice versa.

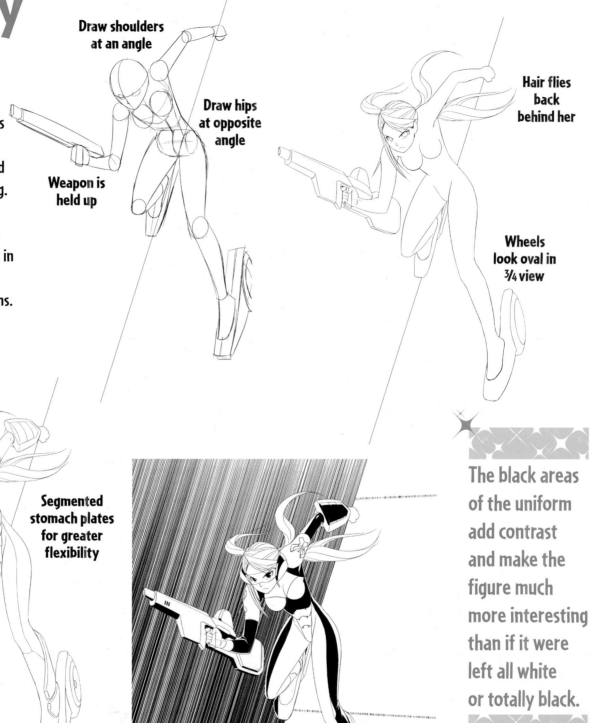

Draw shoulders at an angle

Draw hips at opposite angle

Weapon is held up

Hair flies back behind her

Wheels look oval in ¾ view

Segmented stomach plates for greater flexibility

The black areas of the uniform add contrast and make the figure much more interesting than if it were left all white or totally black.

58

Spywear

She's got a laser rifle, but that's not quite enough to show that she's a futuristic secret agent. Her costume features side head guards, arm guards, stomach plates, and lower leg guards, too. And she also wears goggles. When you're rolling down the front of a high rise at 100-plus mph, the last thing you need is a gnat in your eye!

Amazing Samurai

She's a master with a blade. So don't get her mad, or you'll be sorry—very, very sorry. Notice the way she swings the sword—with a straight arm held far away from the body. Not tight, bent or cramped. That just wouldn't be graceful enough. She wears the traditional samurai outfit—a flowing robe with armor and sandals.

Sword is an extension of the arm

Grips second sword (just in case)

Leans forward into the strike

Head down, (don't show the neck)

Long ponytail is traditional

Billowing sleeves

Armor

Sandals may seem a little casual to wear in a fight to the death, but they are a very traditional part of samurai costumes.

Robe almost touches the ground

Split-toe sandals

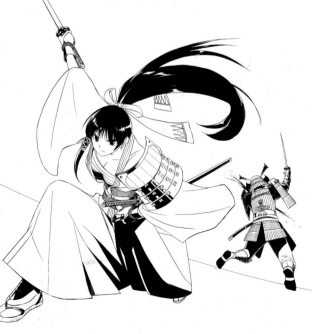

This is a classic samurai battle scene. The two fighters have run toward each other, taken their best shots and continued past one another in their follow-throughs. The next panel would show the guy samurai looking down at his stomach, seeing a bloody slash across it. (Look closely at the enemy's torso and you can see blood spurting out from either side.) He would then buckle at his knees and fall to the ground, face first, wishing he hadn't told her that she fights like a girl. Even though she does— a really mean samurai girl.

Dark Angel

Not all angels are good. Some are very, very bad. But they can also be alluring and beautiful. To make her awe-inspiring, give her gigantic wings and curve them so that they surround her in a luxurious manner. Note the leather straps, which are de rigueur for bad girls.

Wings form an arc at the top

Several interior layers of feathering

Light and Dark

For a powerful contrast between light and dark, blacken out the interior of the wings and of her skirt. Leave a few long, light-colored individual feathers on the exterior of the wings to contrast with the interior. For even more contrasting black, add the reflections of her skirt—drawn precisely in the opposite direction of the real skirt—and of the tips of the wings.

Sketch a guideline for bottom of wings to keep feathers aligned

Zigzagged skirt hem

Leave some white sections to represent the shiny parts

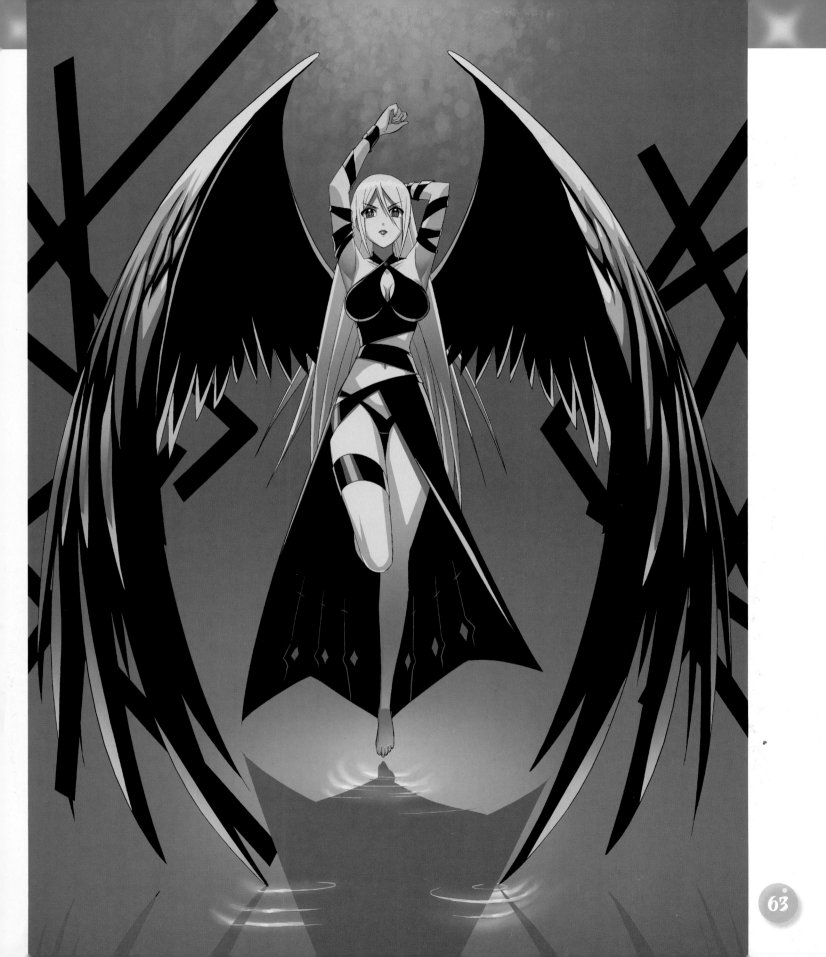

Angel of Light

Now let's take a look at a "good" angel. She wears a looser garment than the dark angel, and with her jewelry, she looks like she could be a primitive princess. This pose calls for some serious foreshortening. Don't be shy about it. Make the foreshortening effect obvious.

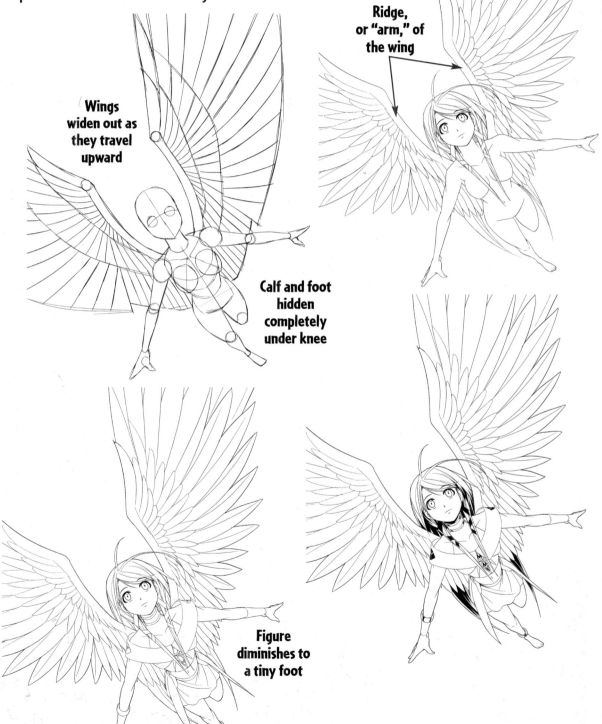

Ridge, or "arm," of the wing

Wings widen out as they travel upward

Calf and foot hidden completely under knee

Figure diminishes to a tiny foot

Hint

If you want to show the wings extended, this is the best way to do it: Draw them fanning upward rather than going straight out to the sides.

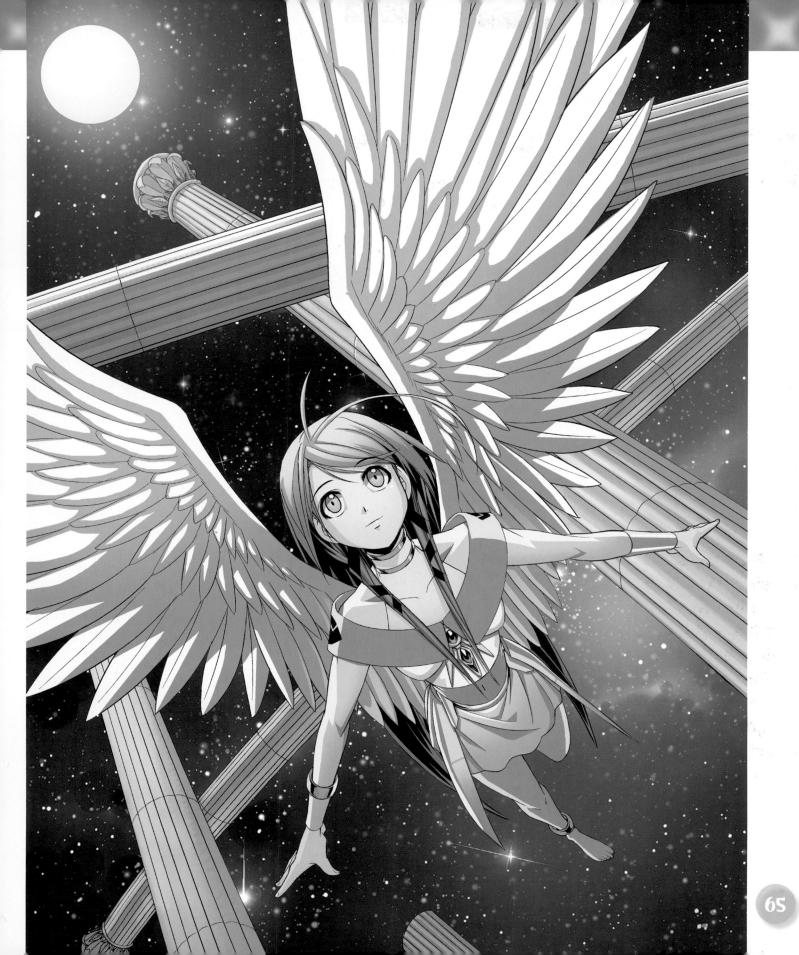

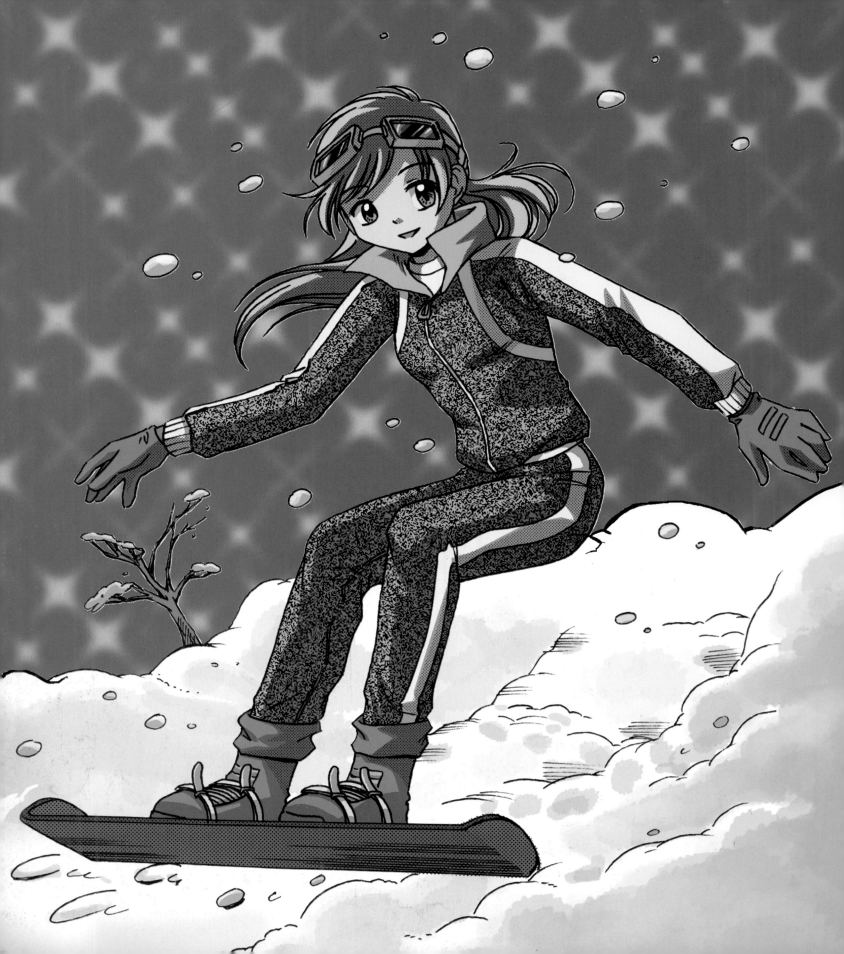

Girl Athletes

Just like America, Japan is crazy for girls' sports. And an entire manga genre has sprung up around the subject. It's good gal versus bad gal, with our hero gal facing the opposing team's bigger, meaner star in a cruel face-off. The girls on the enemy team usually get the upper hand early on, but our hero fights back with guts and courage to win in the end! There's a lot of off-court drama, too, to keep things interesting.

Field Hockey Champ

What used to be an obscure sport has grown by leaps and bounds into one of the most popular outdoor events. In drawing poses for field hockey, it's important to keep the stick and arms away from the body. You don't want them to overlap the torso, which would make the drawing look cramped and hard to read. Be sure to space the hands apart on the stick for more stability. Remember, it's not a baseball bat.

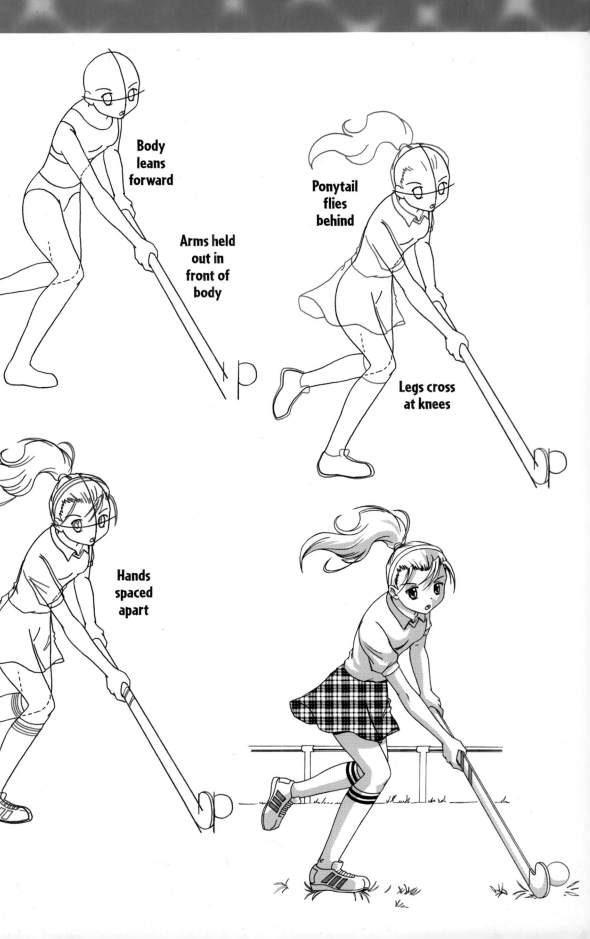

Body leans forward

Arms held out in front of body

Ponytail flies behind

Legs cross at knees

Hands spaced apart

Flapping skirt shows motion

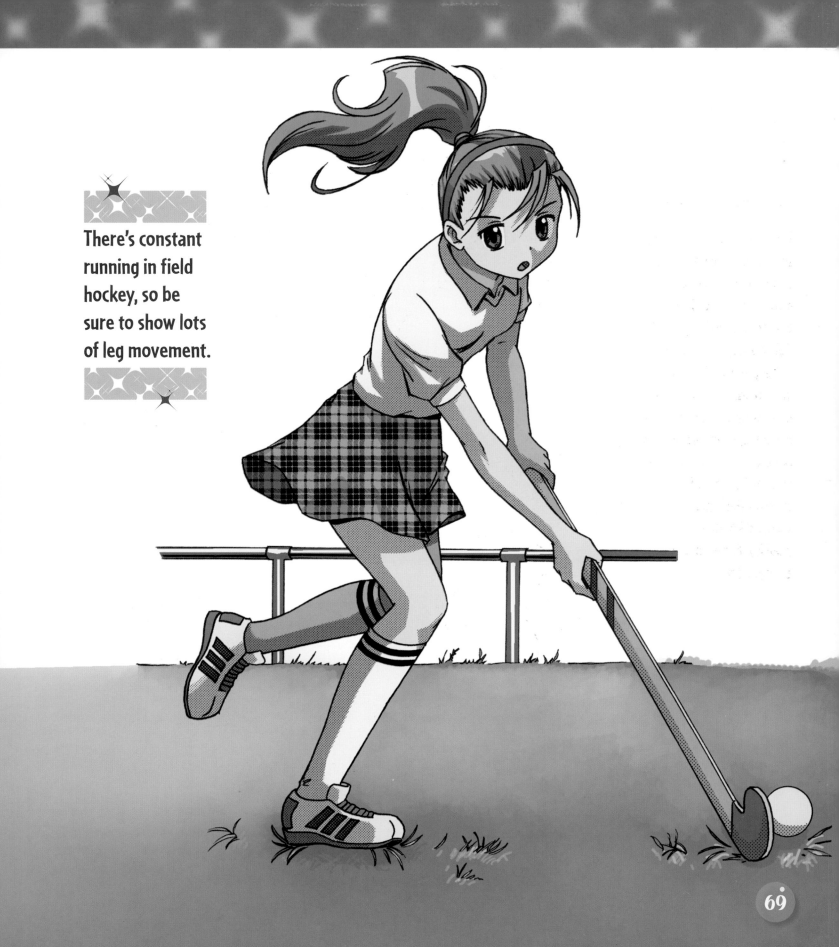

There's constant running in field hockey, so be sure to show lots of leg movement.

Tennis Ace

Tennis has always been popular, but the graphic novel series *The Prince of Tennis* has really rocketed it to the top of the manga world. Short skirts and short-sleeve shirts with headbands, and often wristbands, are the standard tennis costume. Sometimes, a character will wear a visor. But no pro tennis player competes wearing sunglasses.

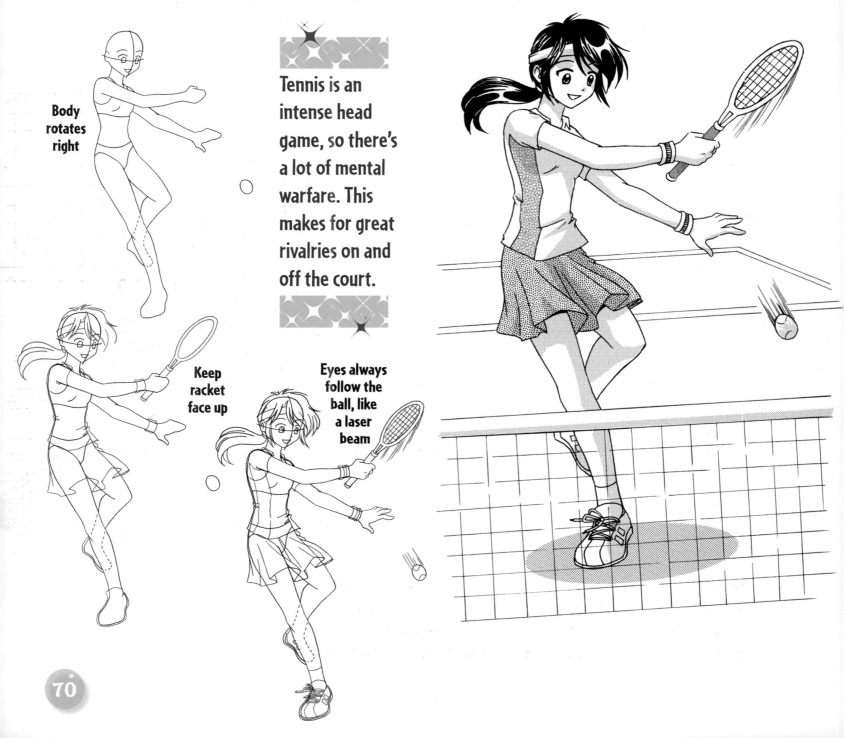

Body rotates right

Tennis is an intense head game, so there's a lot of mental warfare. This makes for great rivalries on and off the court.

Keep racket face up

Eyes always follow the ball, like a laser beam

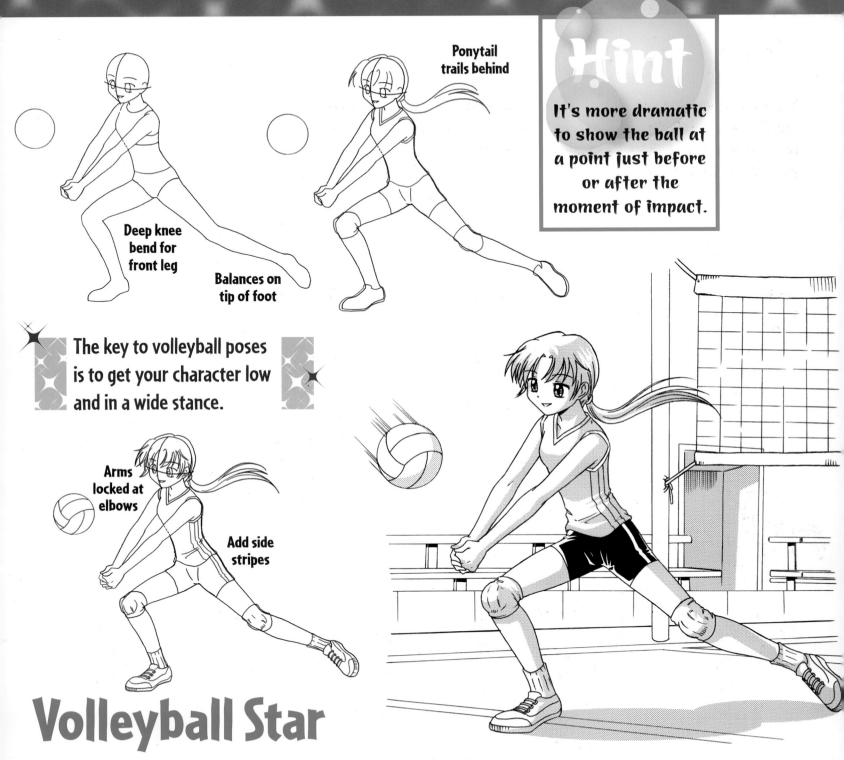

Ponytail trails behind

Deep knee bend for front leg

Balances on tip of foot

Hint

It's more dramatic to show the ball at a point just before or after the moment of impact.

The key to volleyball poses is to get your character low and in a wide stance.

Arms locked at elbows

Add side stripes

Volleyball Star

The underhand return, shown here, is the quintessential volleyball move—something you don't see in any other sport. It's always good to use a signature play when representing a particular sport. That way, the reader "gets it" at a glance. Notice how she's moving forward to meet the ball. All good athletes, in any sport, do this—they anticipate the ball.

Teen Equestrian

There are two types of riding: Western style–the way cowboys ride–and English. English riding, shown here, is more traditional and requires that fancy riding uniform. English riding horses, like their riders, are the epitome of class and good breeding. The horse and rider form a special bond. They read each other's thoughts, become jealous of other's affections, and can come to each other's rescue when one of them is in trouble.

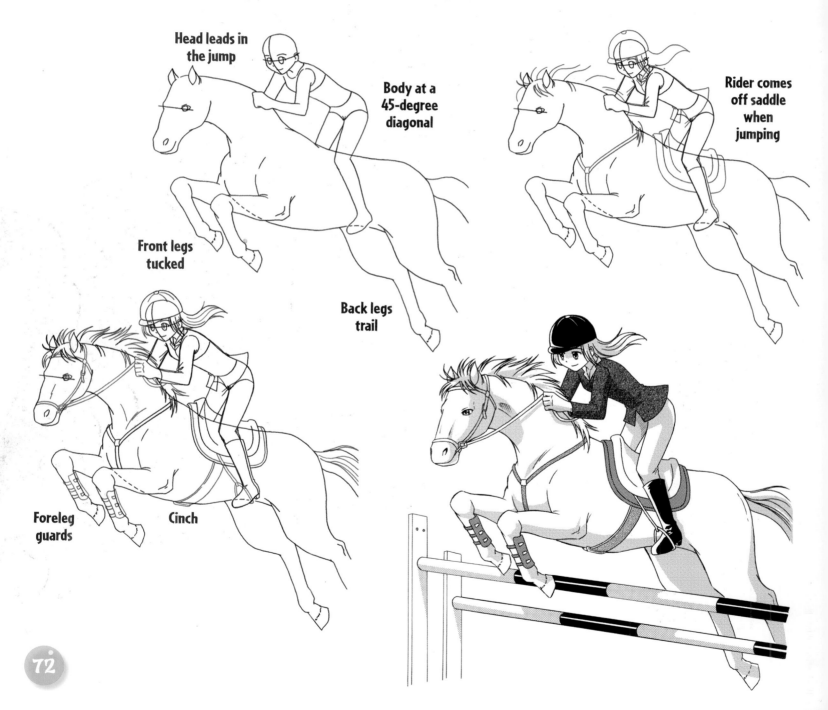

Head leads in the jump

Body at a 45-degree diagonal

Rider comes off saddle when jumping

Front legs tucked

Back legs trail

Foreleg guards

Cinch

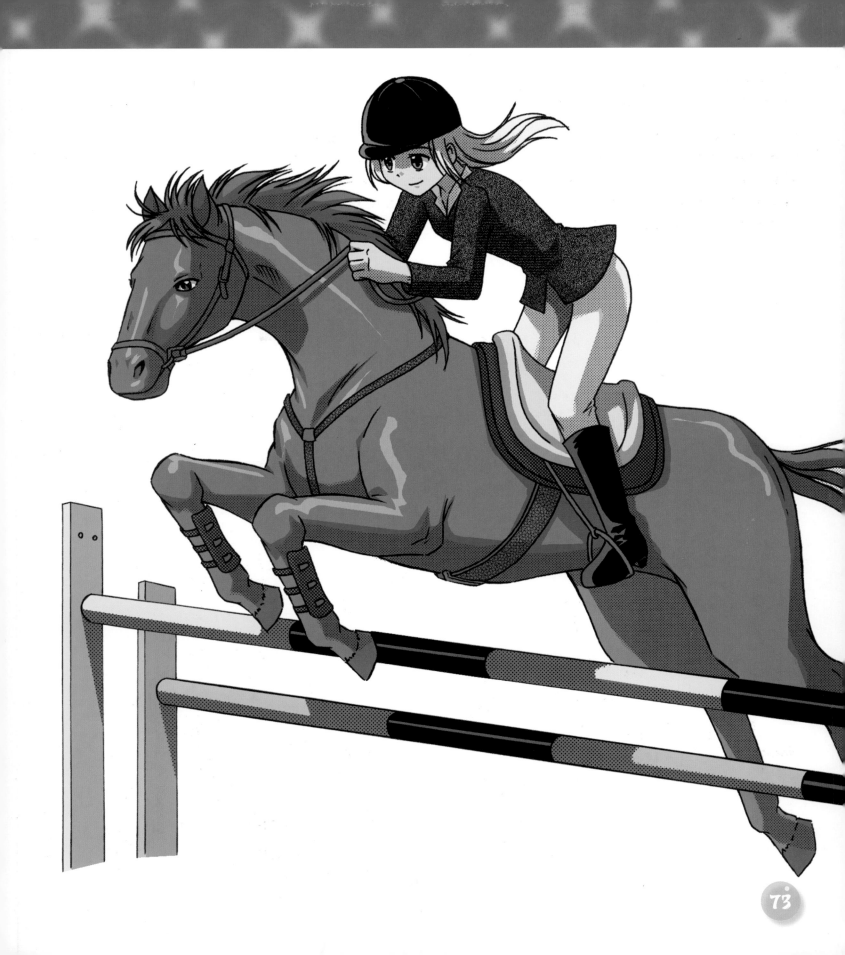

Karate Girl

There are two general types of martial arts: striking and grappling. Striking arts include karate, tae kwon do and kung fu. Grappling arts include judo, jujitsu and aikido. In the striking arts, there are drills, sparring and board (or brick) breaking. Each is exciting. Here, we see a typical karate exercise—breaking boards on top of cinderblocks. The gym where she practices is called a dojo.

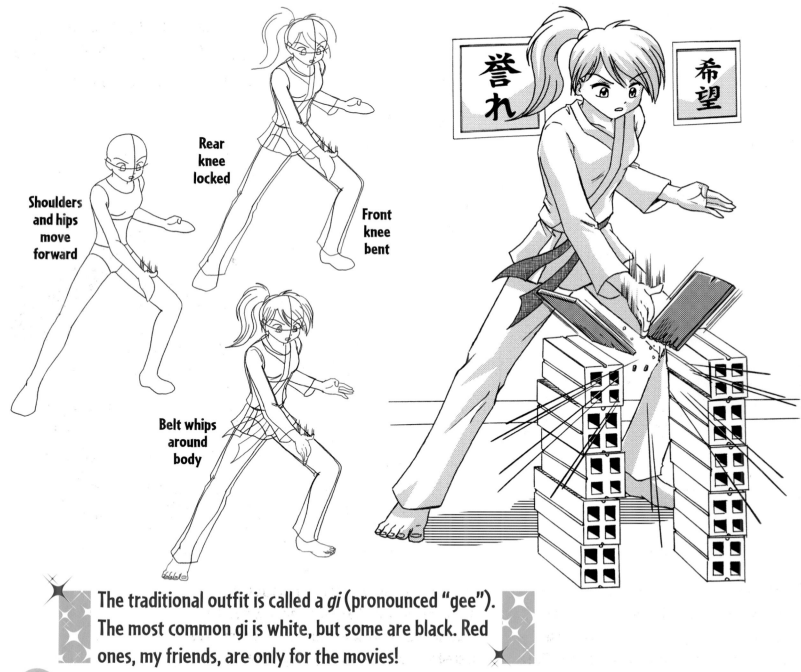

Shoulders and hips move forward

Rear knee locked

Front knee bent

Belt whips around body

誉れ

希望

The traditional outfit is called a *gi* (pronounced "gee"). The most common gi is white, but some are black. Red ones, my friends, are only for the movies!

Body leans forward

Edge of board held up

Slight bend for relaxed-looking arms

Deep bend at knees

Place the goggles high up on her head, so they don't hide those sparkling manga eyes!

Hands out wide for balance

Snowboarder

Let's not forget the ever-popular winter sports! If you look out at the ski slopes from atop a chair lift, one thing is plainly obvious: The younger set is on snowboards, and the old folks are on skis. On skis, you keep the tips up, but on snowboards, it's the side edge that must be kept raised. It sprays the snow forward and allows you to steer. The feet are locked into the snowboard, parallel to each other.

Princess Power!

Princesses in manga run the gamut from the earthbound to the intergalactic. There are good ones, bad ones, ones who sit around looking pretty and ones who fight alien invaders. But they're all attractive and youthful. Although many wear tiaras, it's not essential, especially for warrior types. They mostly live in fantasy castles, which can be located in valleys, on mountaintops, in the middle of lakes, high up in the clouds, or floating in the sky.

Spoiled Princess

This rich girl lives in her daddy's castle. She's given everything she wants. But what if she falls in love with a pauper who comes from the wrong side of the moat? What if Daddy threatens to cut her off from all of her worldly possessions and creature comforts? Which would she choose, true love or a life of luxury and splendor?

This type of princess, who comes from a long line of nobility, almost always has long hair and wears a small tiara.

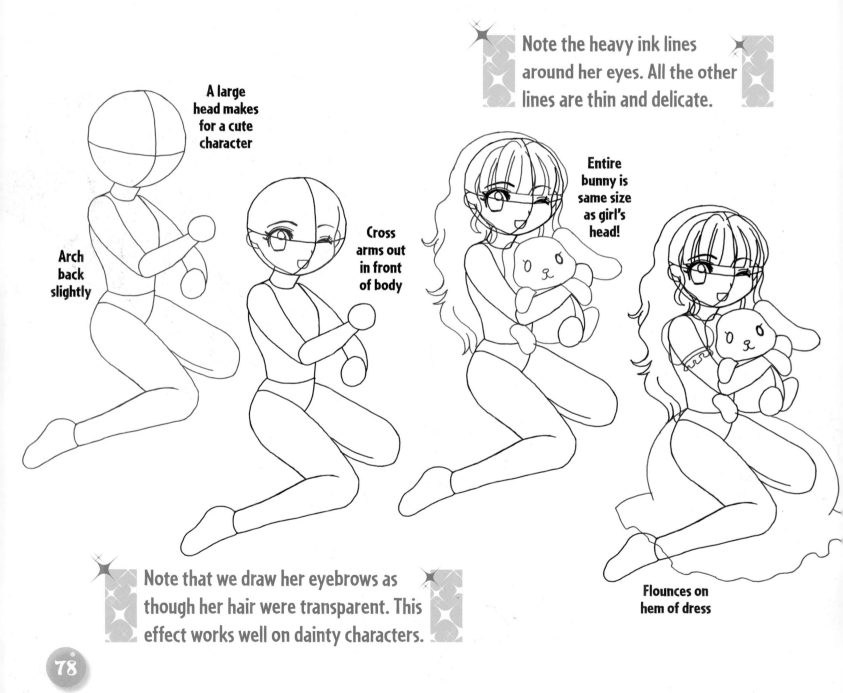

A large head makes for a cute character

Arch back slightly

Cross arms out in front of body

Note the heavy ink lines around her eyes. All the other lines are thin and delicate.

Entire bunny is same size as girl's head!

Note that we draw her eyebrows as though her hair were transparent. This effect works well on dainty characters.

Flounces on hem of dress

Princess Pets

Animals like these are "chibi" types—cute miniature characters. They are built on simple shapes, instead of drawn realistically. They're always small and plump with button eyes and tiny mouths and noses. They are favorites of manga lovers of all ages!

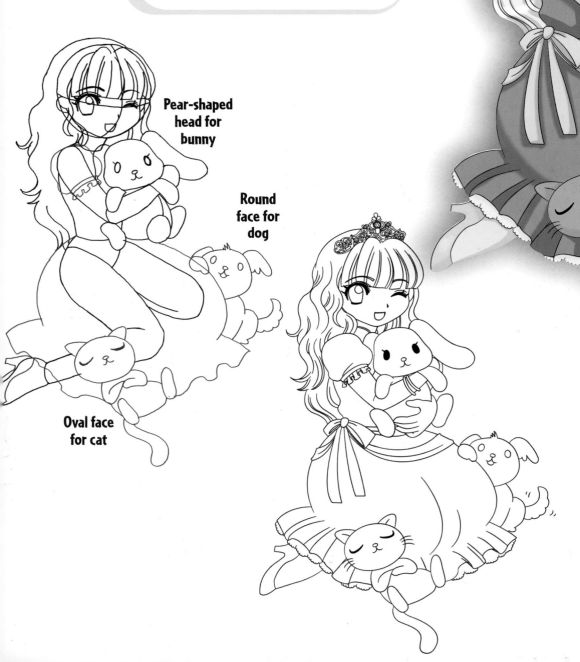

Pear-shaped head for bunny

Round face for dog

Oval face for cat

Princess From Another Galaxy

Space fantasies often feature idealized views of the future, such as advanced kingdoms threatened by interplanetary barbarians seeking to take them over. How better to negotiate for total surrender than to take the planet's princess hostage? All of her subjects love her and would give anything to get her back safe and sound!

Because she's a fantasy character, you can give her a fanciful hair color.

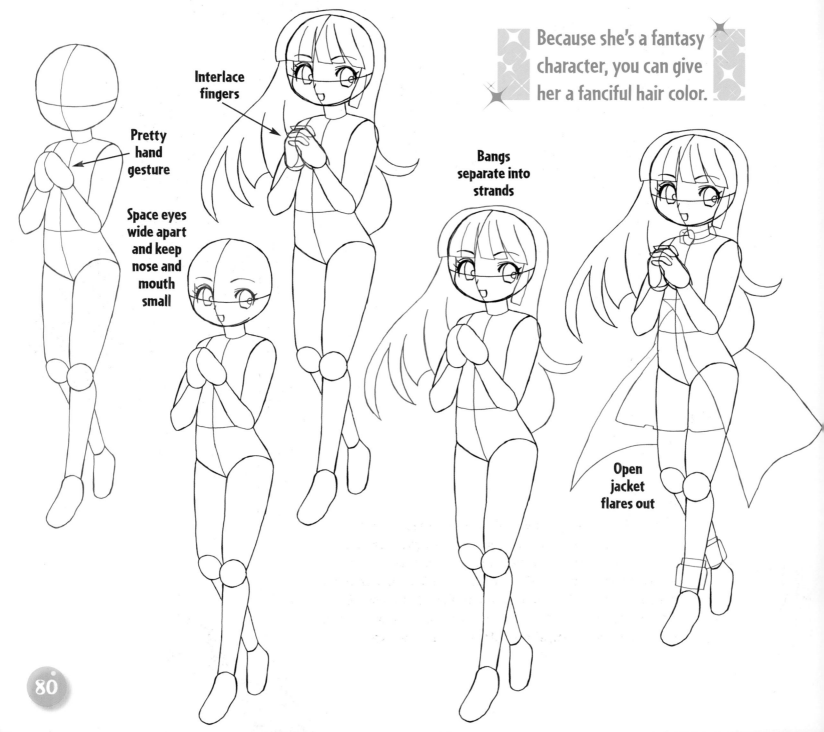

Pretty hand gesture

Interlace fingers

Space eyes wide apart and keep nose and mouth small

Bangs separate into strands

Open jacket flares out

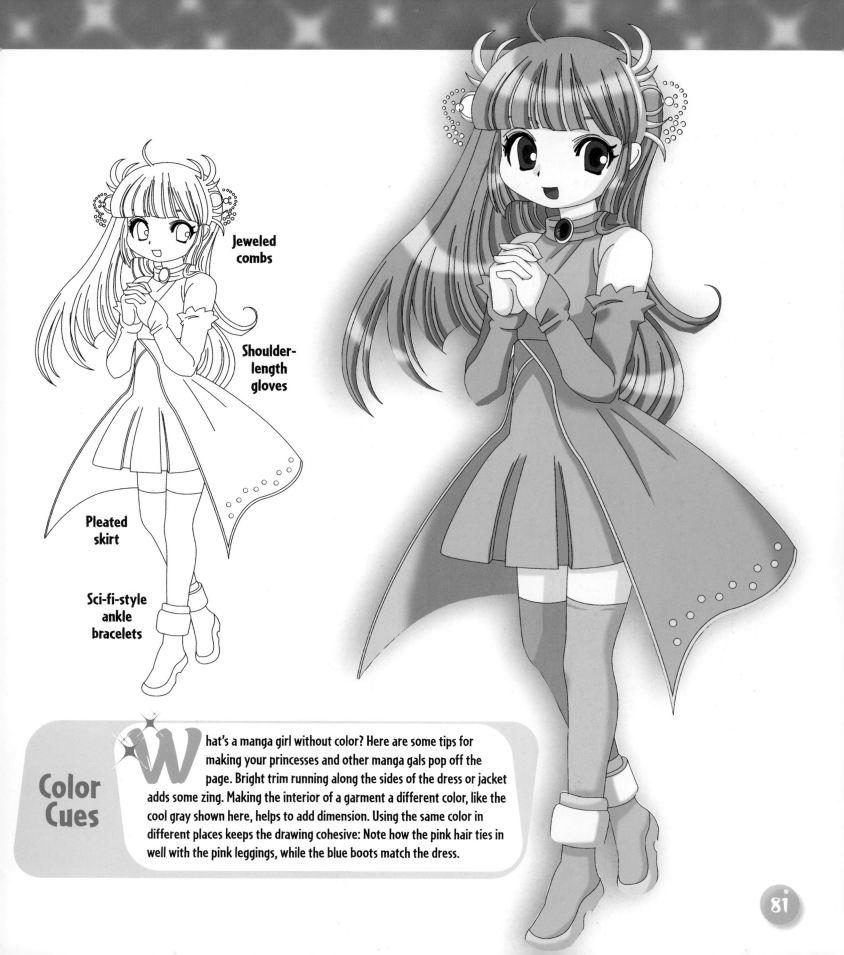

Jeweled combs

Shoulder-length gloves

Pleated skirt

Sci-fi-style ankle bracelets

Color Cues

What's a manga girl without color? Here are some tips for making your princesses and other manga gals pop off the page. Bright trim running along the sides of the dress or jacket adds some zing. Making the interior of a garment a different color, like the cool gray shown here, helps to add dimension. Using the same color in different places keeps the drawing cohesive: Note how the pink hair ties in well with the pink leggings, while the blue boots match the dress.

Fighter Princess

The typical fighter princess is a cross between a knight and a magical girl. The long gloves, short pleated skirt and leggings are pure magical girl genre. She should wear only as much body armor as is necessary. You don't want to cover her up too much, or she'll look bulky. Give her flowing, waist-length fantasy hair, for a glamorous look. She doesn't need a tiara–it's too prissy for a warrior.

Leg compresses underneath

"Push-off leg" drawn at a 45-degree angle

Sharp eyebrows, close to the eyes

Classic fighter hand pose

Ruffles along hem of skirt

Ponytail goes up before it cascades down

Top of chest armor curves down

Top of hip armor and bottom of chest armor curve up

Knee and shoulder guards show she's ready for any opponent

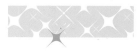

A bit of jewelry—whether it's a jeweled choker or a colorful bangle bracelet—never hurt a fighter girl.

Eye-Catching Color

The grays, lavenders and blues of her costume and hair are all in a similar range of colors, which is why they complement each other so well. The green is a little different, so it stands out. It's used to make her eyes "pop" off the page. The eyes should be the focus of the face.

Evil Princess

If ever there were a character who loved to plot and scheme, it would be the evil princess. She's beautiful, but also cruel. Never satisfied with the amount of power she has, she's always plotting to acquire more. She is often portrayed as part of an evil team—with her as its leader. Evil characters like her often wear tight-fitting bodysuits. High heels complete the severe look.

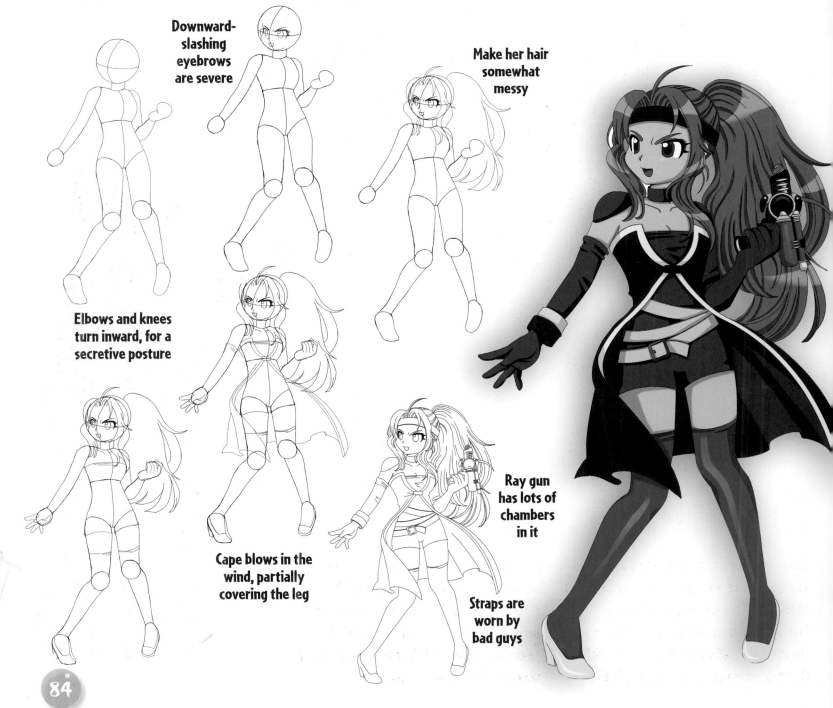

Downward-slashing eyebrows are severe

Make her hair somewhat messy

Elbows and knees turn inward, for a secretive posture

Cape blows in the wind, partially covering the leg

Ray gun has lots of chambers in it

Straps are worn by bad guys

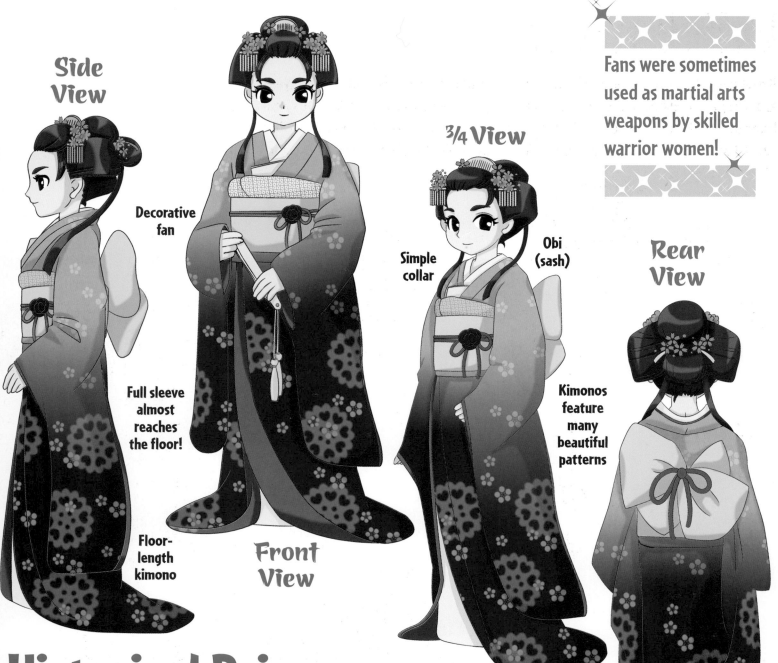

Side View

Decorative fan

Full sleeve almost reaches the floor!

Floor-length kimono

Front View

3/4 View

Simple collar

Obi (sash)

Kimonos feature many beautiful patterns

Rear View

Fans were sometimes used as martial arts weapons by skilled warrior women!

Historical Princess

Historical dramas are very popular in manga. The word history might conjure up thoughts of homework assignments, but these historical stories are not boring, because they're fictionalized period pieces—stories that take place at some cool time in the past with original characters who wear authentic, eye-catching costumes. They often feature princesses, princes, samurai, ninjas, noblemen and warriors. Here is a beautiful, historical princess of feudal Japan wearing the famous kimono.

Pretty Tomboys

Charged with personality, outgoing and assertive, tomboys are out to prove themselves. At every opportunity, they one-up the boys. But sometimes it works against them, because their crushes can find them intimidating. In manga stories, they make great lead characters or resourceful sidekicks who end up on lots of adventures. We'll also take a look at the gender-bender genre, which features humorous stories of girls dressing like boys (and vice versa).

Regular Manga Girls Vs. Tomboys

The typical manga girl wears the classic Japanese school uniform—a short jacket and pleated skirt—with a few optional items to make a personal fashion statement, like leggings, tights and stylish boots.

The pretty tomboy wears clothes that aren't so polished or stylish. She wears clothes she can mess around or play sports in. This typical tomboy wears a baseball jersey and short cargo pants. She has short, carefree hair.

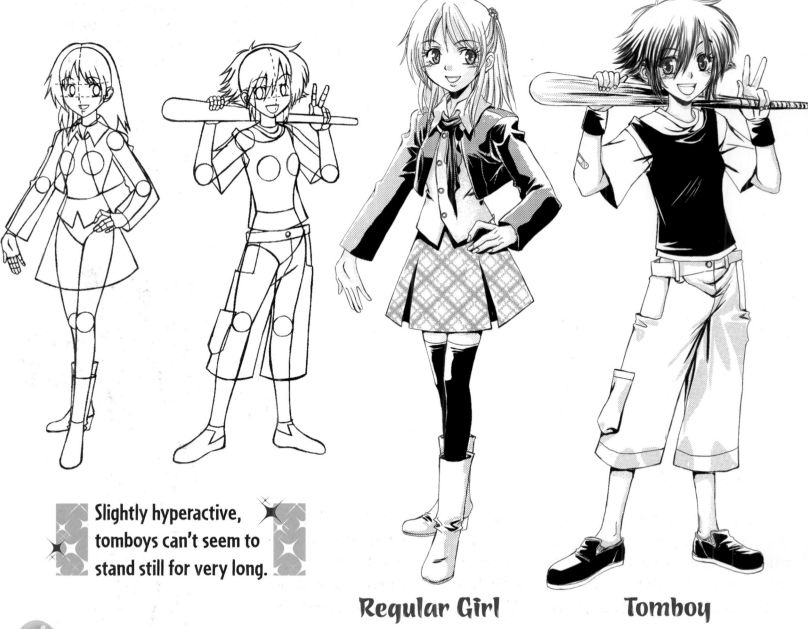

Slightly hyperactive, tomboys can't seem to stand still for very long.

Regular Girl **Tomboy**

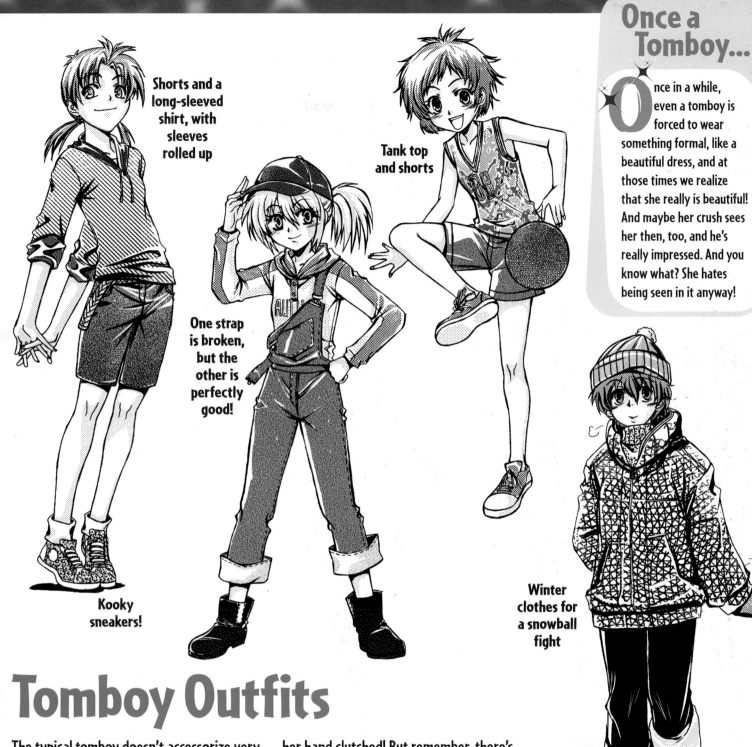

Shorts and a long-sleeved shirt, with sleeves rolled up

Tank top and shorts

One strap is broken, but the other is perfectly good!

Kooky sneakers!

Winter clothes for a snowball fight

Once a Tomboy...

Once in a while, even a tomboy is forced to wear something formal, like a beautiful dress, and at those times we realize that she really is beautiful! And maybe her crush sees her then, too, and he's really impressed. And you know what? She hates being seen in it anyway!

Tomboy Outfits

The typical tomboy doesn't accessorize very well, and her clothing doesn't always quite match, which can be humorous. She should look as if she reached into her closet with her eyes closed and selected the first thing her hand clutched! But remember, there's still a pretty girl under there, so you don't want to portray her as unattractive or as a slob. She's just not interested in fashion at this point, in the same way that boys aren't.

Girls Rule!

How intensely humiliating. The high school jock has been bested by a girl. Yes!! She lives for these moments! Yet, for all of her victories, what she really wants, deep inside, is to be liked, not to make him feel bad. But she doesn't know how to tell him how she feels, and he has no idea that she really has a crush on him!

To draw this scene, position the characters close together. The farther apart they are, the weaker the action will look. And since we are looking down at the table, draw it in simple perspective, as shown here.

Due to perspective, the table looks bigger when it's closer to us and smaller when it's far away.

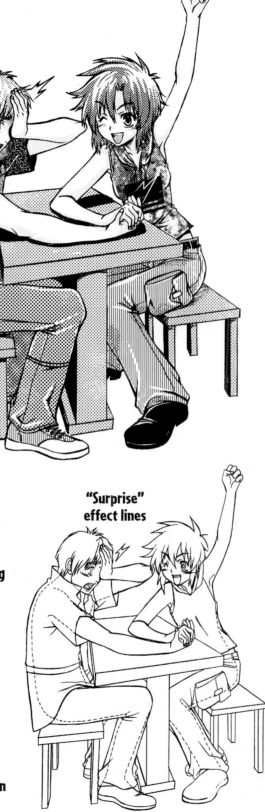

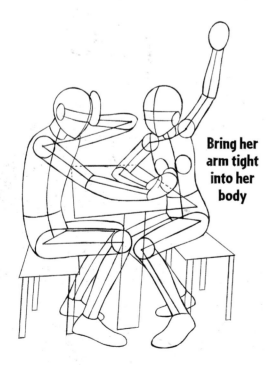

Bring her arm tight into her body

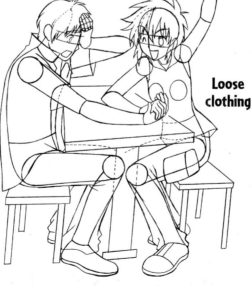

Big expressions on both faces!

Loose clothing

Body twists to face forward while legs remain in profile position

"Surprise" effect lines

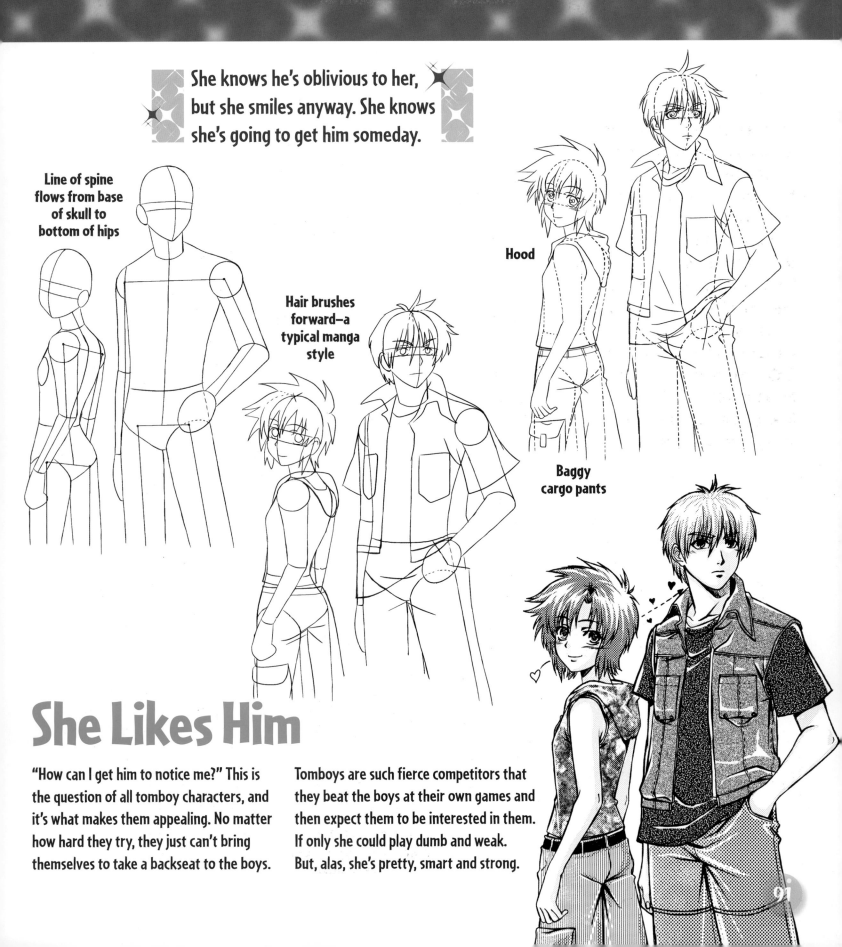

She knows he's oblivious to her, but she smiles anyway. She knows she's going to get him someday.

Line of spine flows from base of skull to bottom of hips

Hair brushes forward—a typical manga style

Hood

Baggy cargo pants

She Likes Him

"How can I get him to notice me?" This is the question of all tomboy characters, and it's what makes them appealing. No matter how hard they try, they just can't bring themselves to take a backseat to the boys.

Tomboys are such fierce competitors that they beat the boys at their own games and then expect them to be interested in them. If only she could play dumb and weak. But, alas, she's pretty, smart and strong.

Tug of War!

Here's my public service announcement: Never get into a tug-of-war match with a tomboy. It's like trying to take a bone from a junkyard dog. The scene, however, can be a very humorous one for manga artists. It can end up in a dust cloud of action. Or, both characters can go chibi, with wild and broad expressions. One thing's for sure: She will never, ever let go. She probably doesn't even want the book anyway. She just hates to lose.

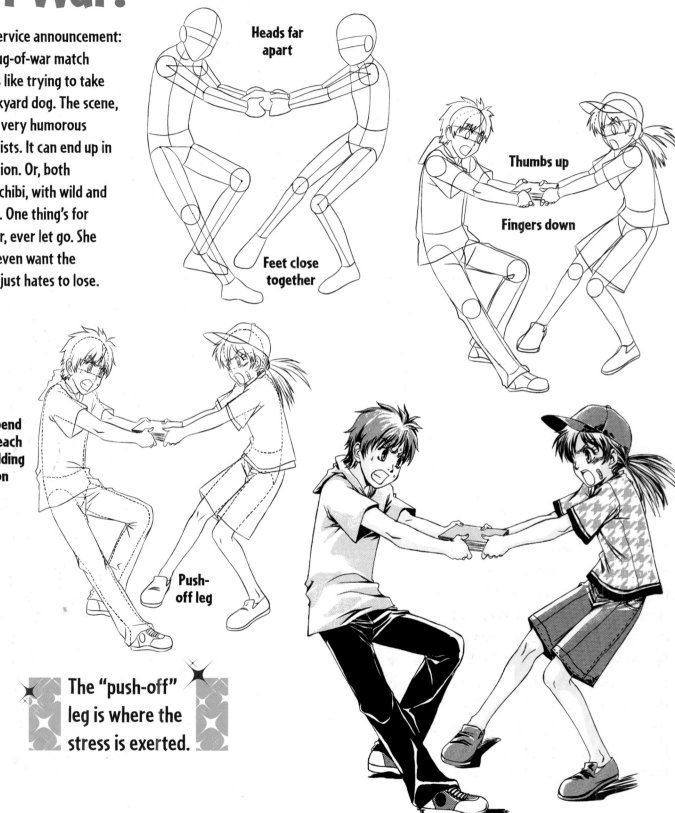

Heads far apart

Feet close together

Thumbs up

Fingers down

Bodies bend toward each other, adding tension

Push-off leg

The "push-off" leg is where the stress is exerted.

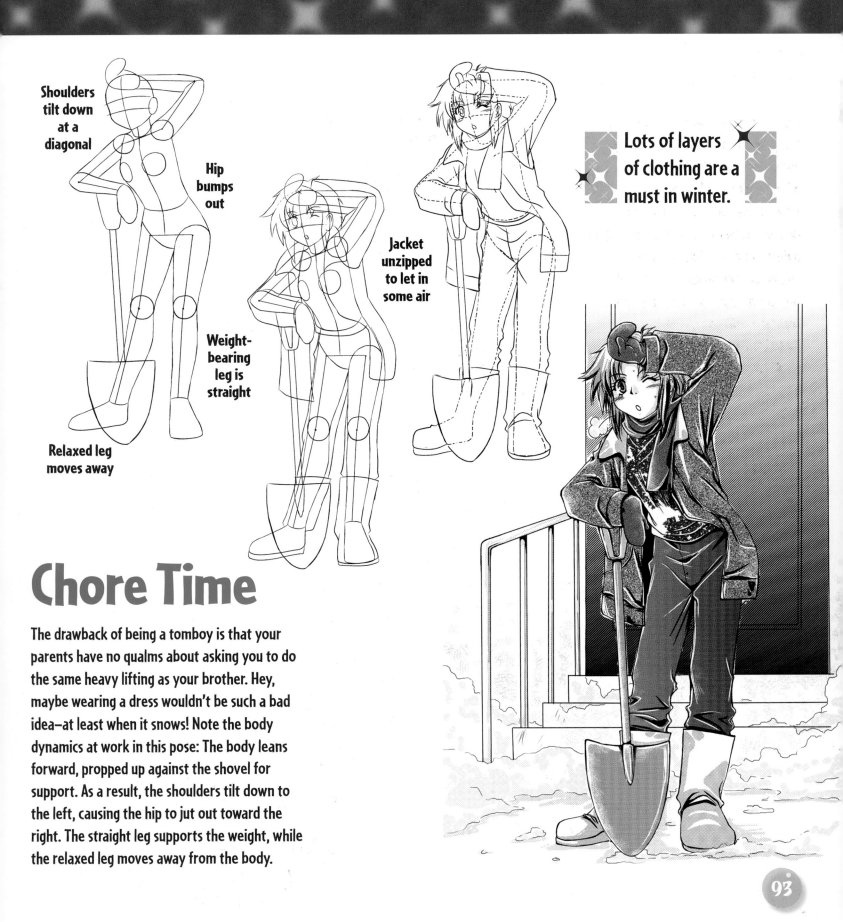

Shoulders tilt down at a diagonal

Hip bumps out

Weight-bearing leg is straight

Relaxed leg moves away

Jacket unzipped to let in some air

Lots of layers of clothing are a must in winter.

Chore Time

The drawback of being a tomboy is that your parents have no qualms about asking you to do the same heavy lifting as your brother. Hey, maybe wearing a dress wouldn't be such a bad idea—at least when it snows! Note the body dynamics at work in this pose: The body leans forward, propped up against the shovel for support. As a result, the shoulders tilt down to the left, causing the hip to jut out toward the right. The straight leg supports the weight, while the relaxed leg moves away from the body.

Gender Bender!

Now we turn to girls who not only act like boys, but actually pretend to *be* boys! The gender-bender genre is featured in many funny graphic novels. These are comic stories in which girls dress as boys—and vice versa—to disguise themselves. The trick is to change the character enough so that no one in the story recognizes her, but still have her look enough like herself that the reader knows it's her.

Change to boy's hair, but make it somewhat androgynous

Hand in pocket is a slightly more masculine pose

All accessories have to go

Disguised as a boy

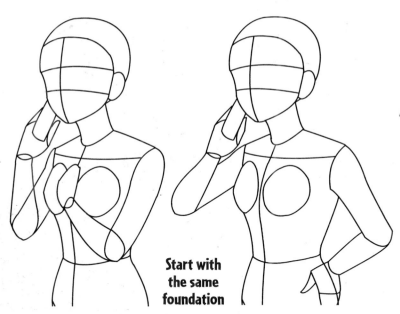

Start with the same foundation

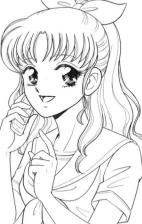

School uniforms—like the Nehru jacket—work best, because they're nondescript.

Step by Step

The underlying structure of the head and body remain identical for both "genders" of the character. It's only the details—the costume, hairstyle and pose—that change.

Hint There are specific things we should alter about her appearance, and things we should not. For example, the eyes should remain the same; otherwise, we lose the essence of the character.

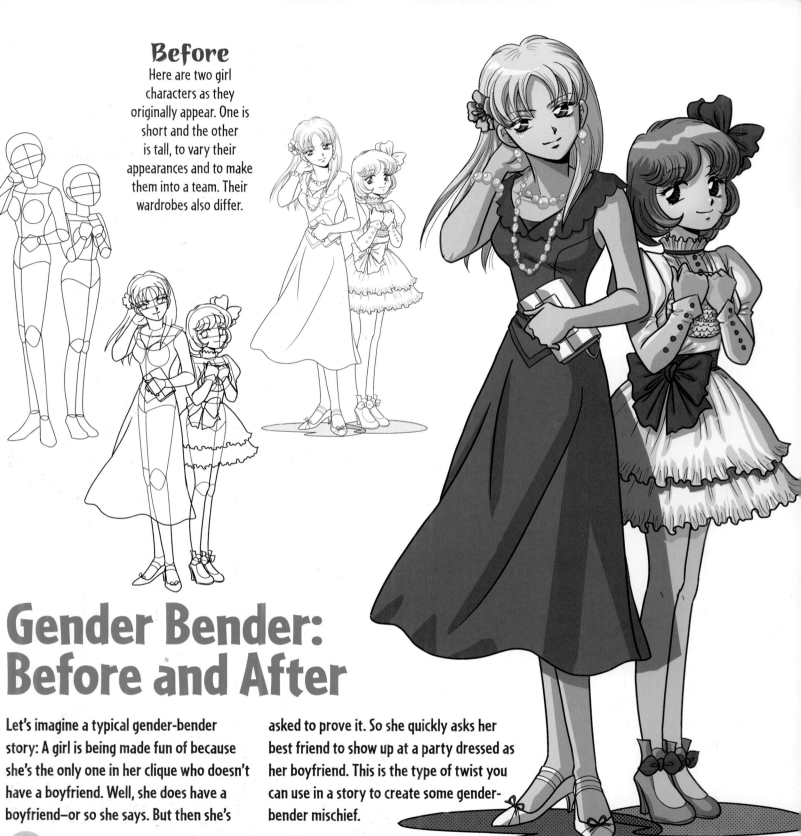

Before

Here are two girl characters as they originally appear. One is short and the other is tall, to vary their appearances and to make them into a team. Their wardrobes also differ.

Gender Bender: Before and After

Let's imagine a typical gender-bender story: A girl is being made fun of because she's the only one in her clique who doesn't have a boyfriend. Well, she does have a boyfriend–or so she says. But then she's asked to prove it. So she quickly asks her best friend to show up at a party dressed as her boyfriend. This is the type of twist you can use in a story to create some gender-bender mischief.

After

The clothes and hair have changed, and even the pose is more masculine, but these two "boys" are based *entirely* on the two girls on the previous page! In fact, they are the same two girls, but in disguise. Gender bender! The tall one's wink to the reader lets us in on the gag.

Kodomo!

Kodomo is a hugely popular style of manga, and possibly the most popular character type of all time on TV animation (called "anime"). Although you rarely hear the term kodomo mentioned outside of Japan, you know it when you see it. Kodomo characters are young teens who are involved in all sorts of cool adventures. They can be brave, but they're also quite silly and endearing.

Kodomo Style: Keep It Round!

Just making a character look young doesn't automatically turn her into a kodomo-style character. You have to make sure that everything about her is soft and round—there's nothing angular about a kodomo girl.

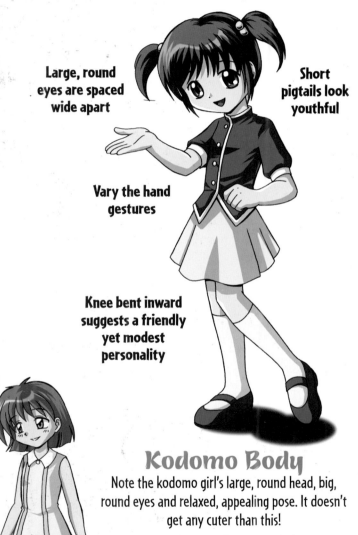

Large, round eyes are spaced wide apart

Short pigtails look youthful

Vary the hand gestures

Knee bent inward suggests a friendly yet modest personality

Kodomo Body
Note the kodomo girl's large, round head, big, round eyes and relaxed, appealing pose. It doesn't get any cuter than this!

Angular Body
Sure she's the kodomo age range and body type, but notice that the outline of her face, her eyes, and her pose are more angular, and stiffer, than the kodomo girl's (whose head is also larger!) As a result, she's not as cute.

Note that the nose and mouth are minimized, which makes the eyes look bigger by contrast.

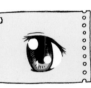

Kodomo Eyes
The overall shape of the eye is based on a rounded square, or a circle.

Angular Eyes
Angular eyes, which are drawn more often by American artists who are trying to imitate Japanese manga, are based on a geometrical shape with sides, like this pentagon.

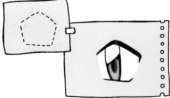

The Kodomo Head

The kodomo face is wide with big cheeks and a little chin. The eyes are large and set wide apart, and the nose is extra-tiny. All of the features are set low on the face, which means that there is a lot of forehead. Make sure you cover it with a bunch of brushy hair. And give your character a thin neck for a youthful look.

Pink hair? Why not!

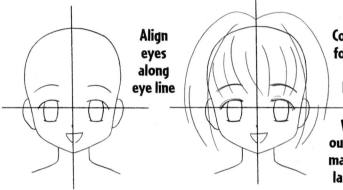

Align eyes along eye line

Cover the forehead with bangs

Widen out hair to make head large and cute

Front View
In the front view, you can see how far apart the eyes are set.

On real people, the iris (colored part of the eye) is much larger than the pupil. But on these cute kodomos, the pupil becomes huge and squeezes out most of the iris.

Profile
Notice that in the side view the ears are close to the middle of the head. Some beginners think that the back of the head stops just behind the ears, but as you can see, there is almost as much head behind the ears as there is in front.

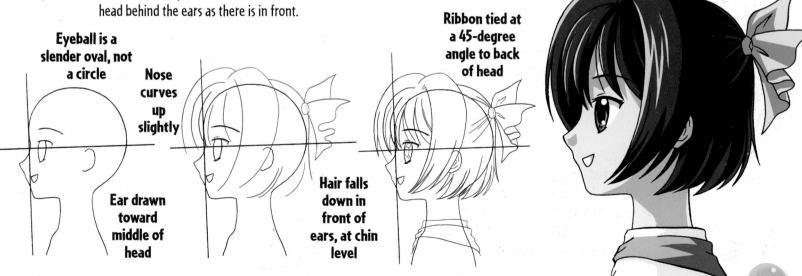

Eyeball is a slender oval, not a circle

Nose curves up slightly

Ear drawn toward middle of head

Hair falls down in front of ears, at chin level

Ribbon tied at a 45-degree angle to back of head

Kodomo Expressions

Here's something I really enjoyed when I was learning to draw–copying expressions. When you copy expressions, you learn much more than just how to draw different faces. You also learn to reproduce characters at many different angles and to make them recognizable in every pose. That's the essence of character design. Without it, no one could tell a sequential story or draw a graphic novel.

Caring
Bottom eyelids push up on the eyes, making them narrower. Eyebrows push upward. A small smile punctuates the expression.

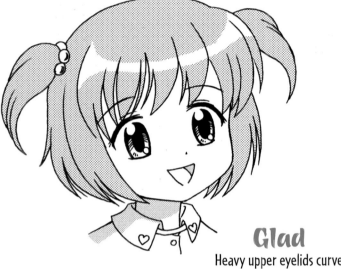

Glad
Heavy upper eyelids curve down. Big shines in the eyes make this expression really sparkle.

Frustrated– Hmmph!
One eyebrow goes down and the other goes up. The eyelids press straight across the eyes. Note the puff of steam!

Delighted
Head tilts, eyes close (note thick eyelashes) and eyebrows arch up. Mouth opens wide.

Angry
Eyebrows crush down on eyeballs. Draw a tense little O for the mouth. And note those emotion lines drawn across her cheek at a diagonal.

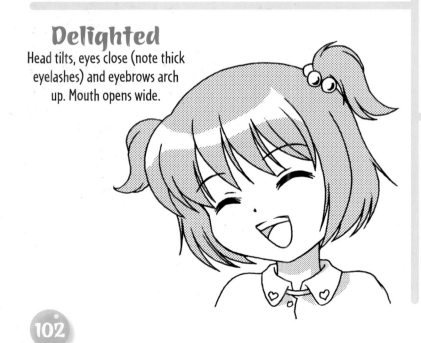

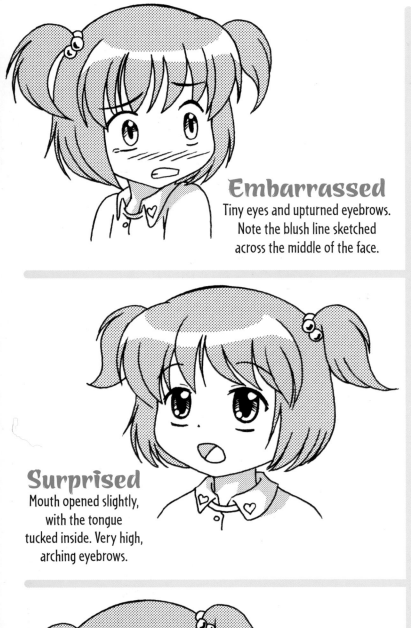

Embarrassed

Tiny eyes and upturned eyebrows. Note the blush line sketched across the middle of the face.

Surprised

Mouth opened slightly, with the tongue tucked inside. Very high, arching eyebrows.

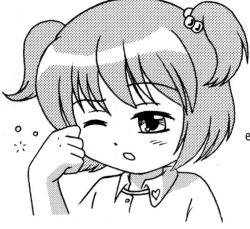

Tired

Squint one eye as her fist rubs against it. The other eye remains half open. Note bubbles of grogginess. If my wife is right, this is how I look before my morning cup of joe.

Crying

The head tilts forward when crying (unless the character is wailing uncontrollably, in a humorous manner).

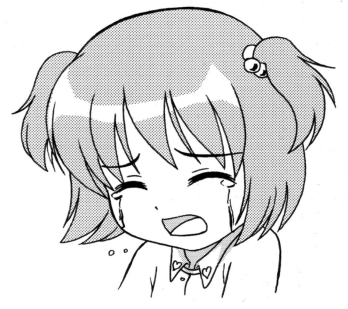

Curious

Focused eyes and a tiny mouth. Eyebrows come together and sweep up in the middle.

The Kodomo Body

Younger characters have rounder heads than older characters. And stringbean bodies work best for kids ages 10 to 12. *Very* young characters, under the age of 10, have plump bodies, but that's too young for the kodomo style. We're looking for a round head on a sliver of a body, which translates into an eager, energetic look.

Oversized head

No hourglass figure on kodomo characters!

Front View

Older teens and adults have wider shoulders and hips, but the torso on kodomo characters is pretty much straight up and down—in a word, girlish. As far as their arms and legs are concerned, don't make them too long and graceful—that's for older characters. And that big head resting on a delicate little neck will guarantee her a sweet and charming look.

Hair usually at least shoulder length, if not longer

Leaning her slightly to the side adds a bit of energy to an otherwise static pose.

Medium-length arms and legs

Head Count

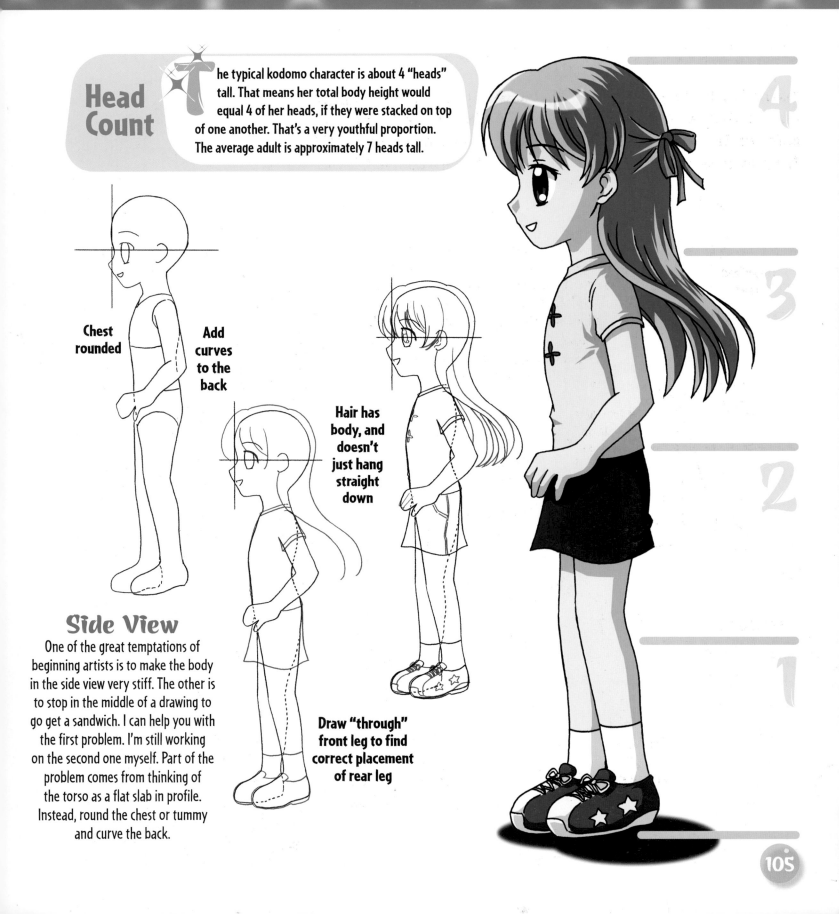

The typical kodomo character is about 4 "heads" tall. That means her total body height would equal 4 of her heads, if they were stacked on top of one another. That's a very youthful proportion. The average adult is approximately 7 heads tall.

Chest rounded

Add curves to the back

Hair has body, and doesn't just hang straight down

Side View

One of the great temptations of beginning artists is to make the body in the side view very stiff. The other is to stop in the middle of a drawing to go get a sandwich. I can help you with the first problem. I'm still working on the second one myself. Part of the problem comes from thinking of the torso as a flat slab in profile. Instead, round the chest or tummy and curve the back.

Draw "through" front leg to find correct placement of rear leg

Action Poses

One thing's for sure—if a kodomo character is standing still, it won't be for long. These high-energy girls are always on the move, whether they're goofing off with friends or competing in sports.

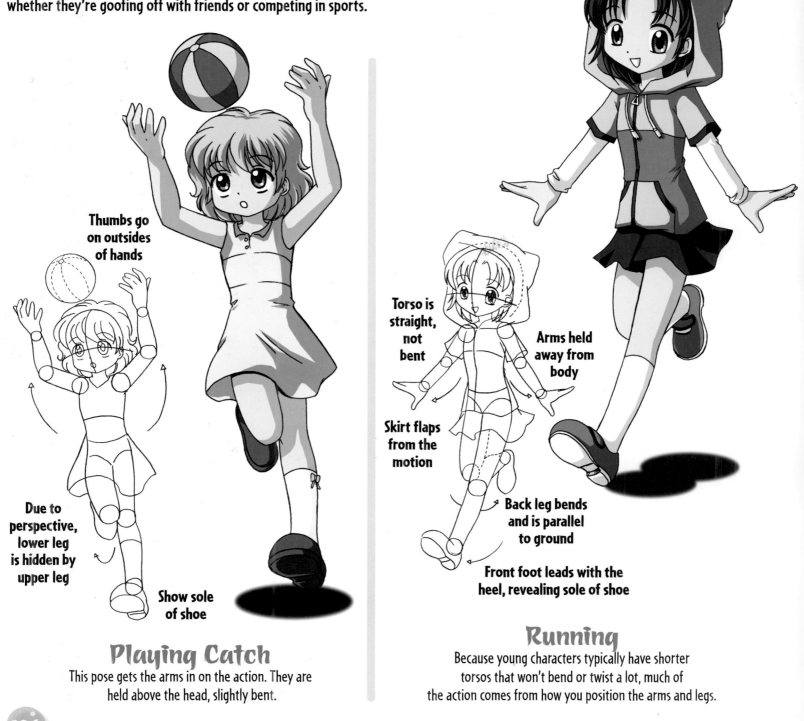

Thumbs go on outsides of hands

Due to perspective, lower leg is hidden by upper leg

Show sole of shoe

Torso is straight, not bent

Arms held away from body

Skirt flaps from the motion

Back leg bends and is parallel to ground

Front foot leads with the heel, revealing sole of shoe

Playing Catch
This pose gets the arms in on the action. They are held above the head, slightly bent.

Running
Because young characters typically have shorter torsos that won't bend or twist a lot, much of the action comes from how you position the arms and legs.

106

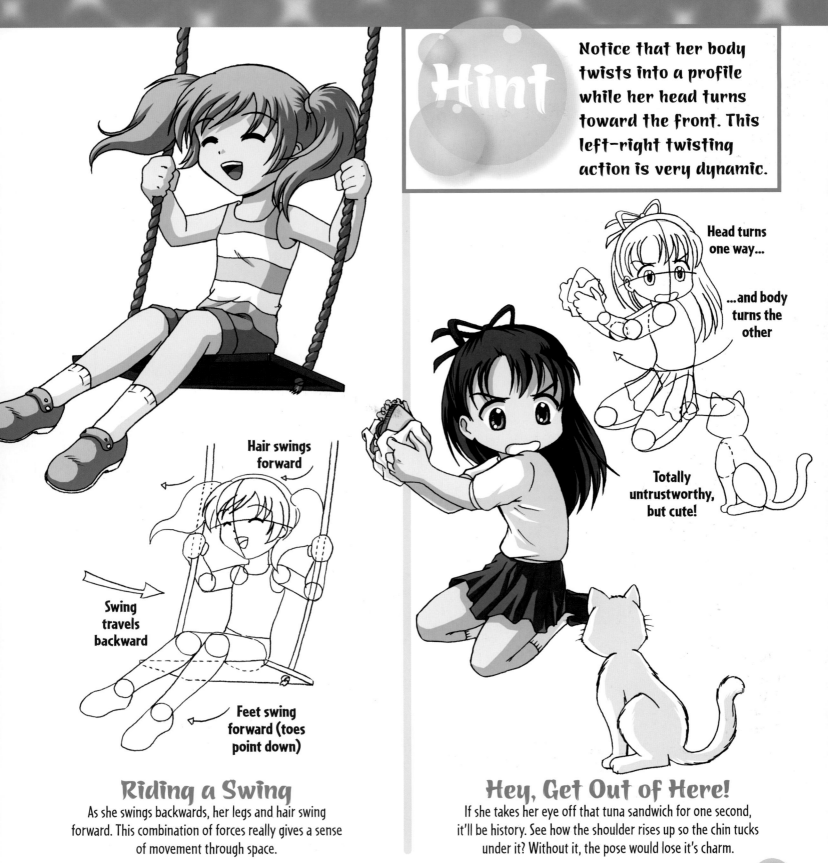

Notice that her body twists into a profile while her head turns toward the front. This left-right twisting action is very dynamic.

Head turns one way...

...and body turns the other

Totally untrustworthy, but cute!

Hair swings forward

Swing travels backward

Feet swing forward (toes point down)

Riding a Swing

As she swings backwards, her legs and hair swing forward. This combination of forces really gives a sense of movement through space.

Hey, Get Out of Here!

If she takes her eye off that tuna sandwich for one second, it'll be history. See how the shoulder rises up so the chin tucks under it? Without it, the pose would lose it's charm.

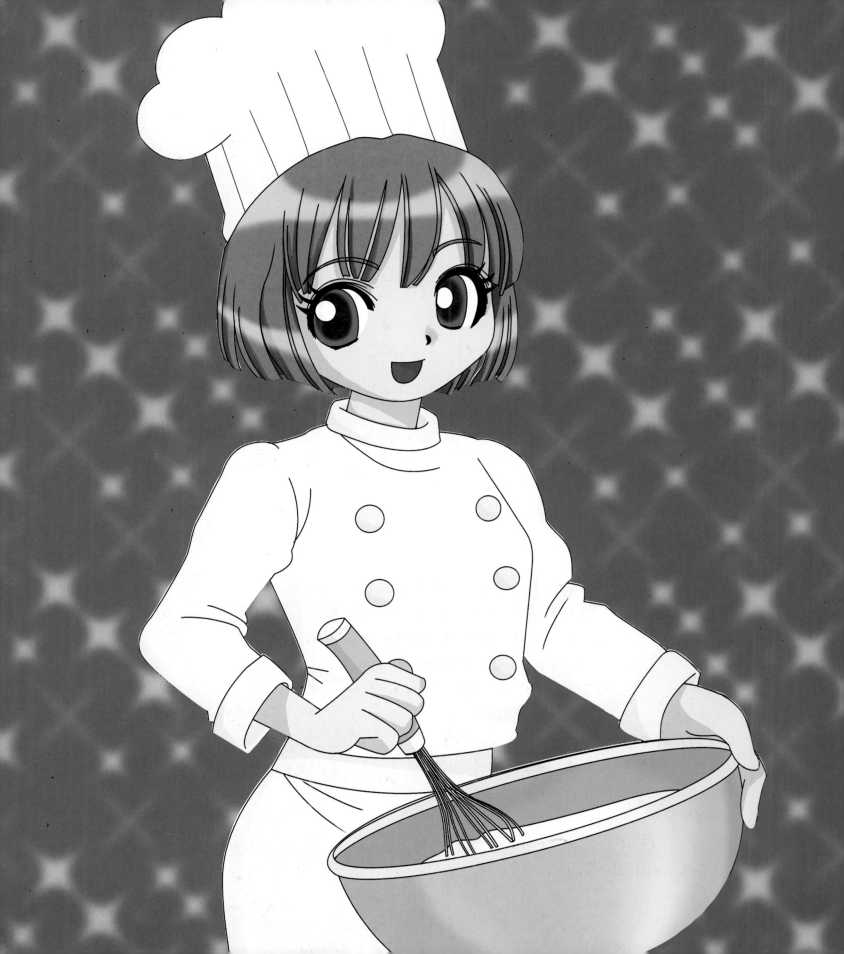

Fantasy Chefs!

O ccupational genres are all the rage in manga these days—and none is more popular than cooking. Japanese youth are obsessed with manga stories that feature young gourmets! Choose an ethnic style of food and dress the cook in an outfit that best represents that country's cuisine. Half the fun is in creating the chefs' costumes, but there is also a lot of humor that goes on in these comics—especially among the apprentice chefs—where anything can, and will, go wrong!

Hibachi Chef

Famous for their work in Japanese steakhouses, hibachi chefs grill all sorts of interesting dishes right before your eyes. They are experts with knives and can slice and dice food in a blur. But the most spectacular aspect of their work is the huge flames that erupt into the air as they grill—it's quite an eyeful.

Hint

Make the burst of flame big and irregular-looking. Fire should always be drawn unevenly; otherwise, it tends to look like a giant flower!

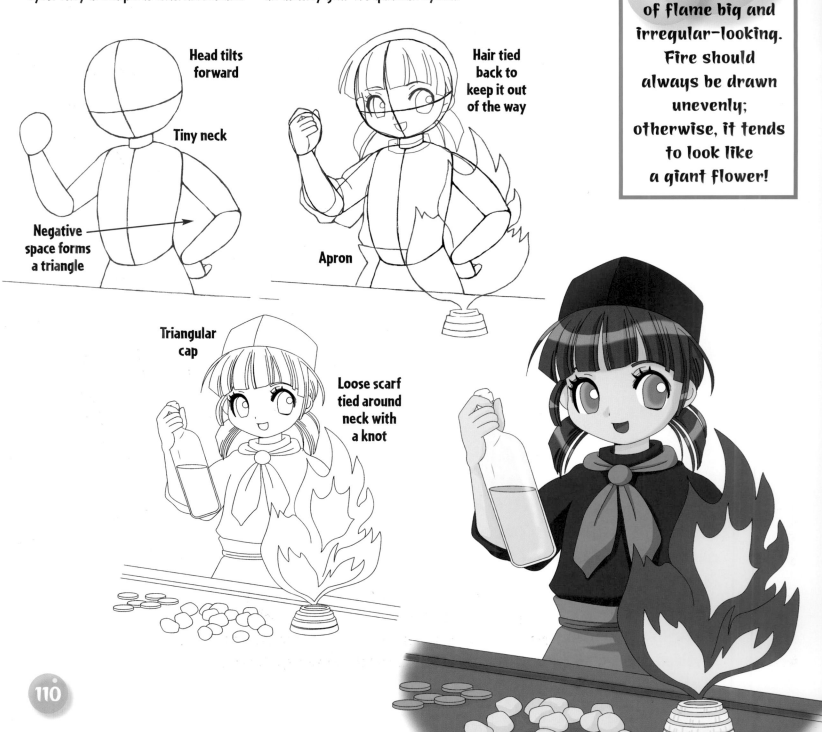

Head tilts forward

Tiny neck

Negative space forms a triangle

Hair tied back to keep it out of the way

Apron

Triangular cap

Loose scarf tied around neck with a knot

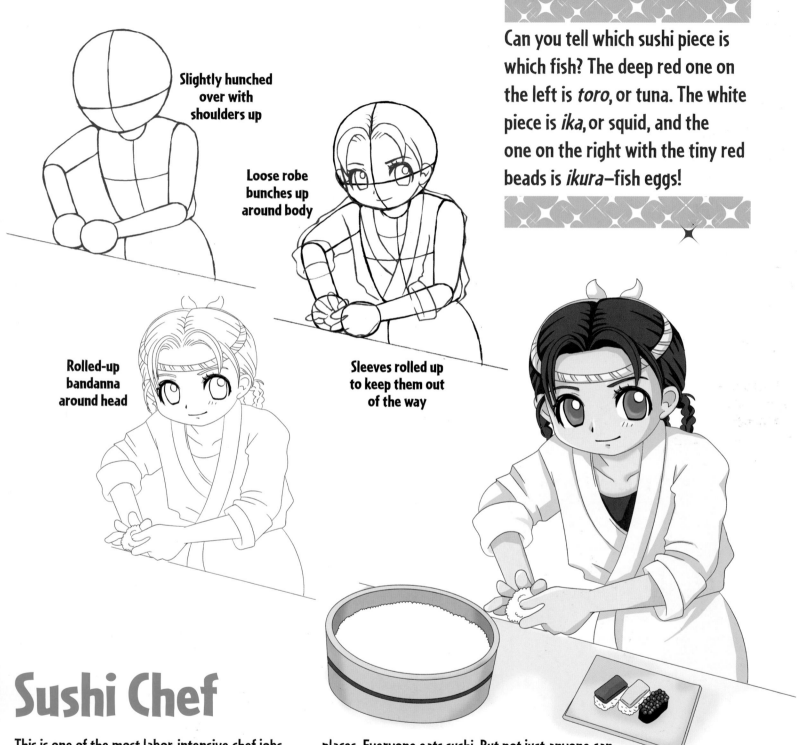

Slightly hunched over with shoulders up

Loose robe bunches up around body

Can you tell which sushi piece is which fish? The deep red one on the left is *toro*, or tuna. The white piece is *ika*, or squid, and the one on the right with the tiny red beads is *ikura*—fish eggs!

Rolled-up bandanna around head

Sleeves rolled up to keep them out of the way

Sushi Chef

This is one of the most labor-intensive chef jobs you could have. Everything is done by hand, using force and pressure. In Japan, they have as many fast-food sushi restaurants as we have hamburger places. Everyone eats sushi. But not just anyone can be a sushi chef. The visual appeal of a well-formed piece of sushi is seen as equally important as its taste, and the sushi chef is a well-respected artisan.

French Chef

The quintessential French chef wears a tall, oversized hat that poufs at the top, along with a button-down jacket. This formal attire shows that she works in a high-end establishment. She's busy mixing up a large bowl of batter to make a fluffy soufflé–*très français!*

Hint

Notice how her eyes really stand out? That's because they are the darkest part of the drawing, which is otherwise colored with a light palette.

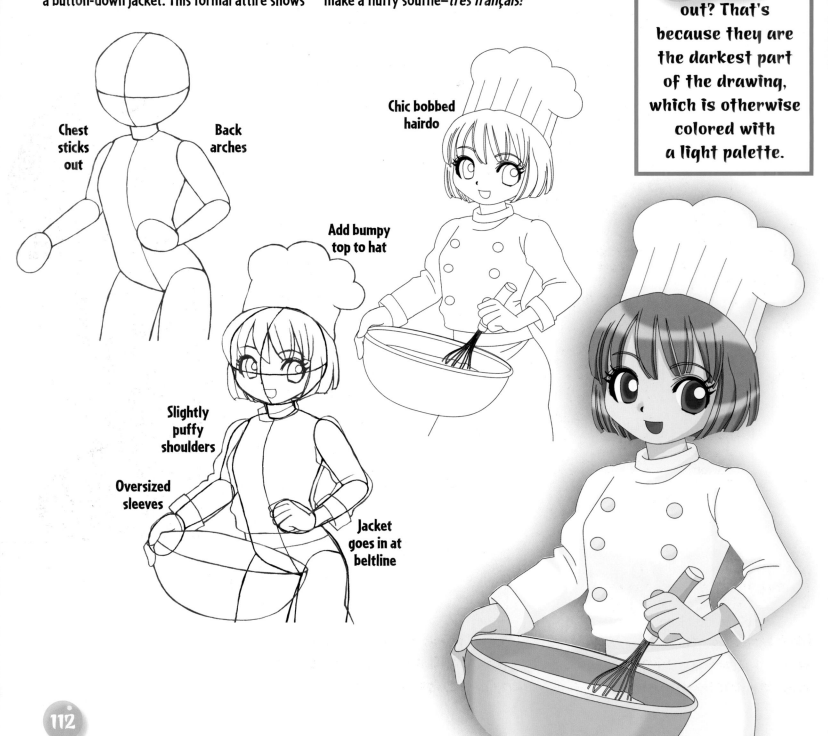

Chest sticks out

Back arches

Chic bobbed hairdo

Add bumpy top to hat

Slightly puffy shoulders

Oversized sleeves

Jacket goes in at beltline

Drawing Dynamic Scenes

This scene could have been drawn with the cake off to the side of the character, instead of in front of her, but that would have flattened the image. Some beginning artists don't want to block part of a figure that they have spent time and energy drawing. But the amount of the figure cut off is minimal, and the result brings the cake closer to the viewer, and to the figure, which energizes the scene.

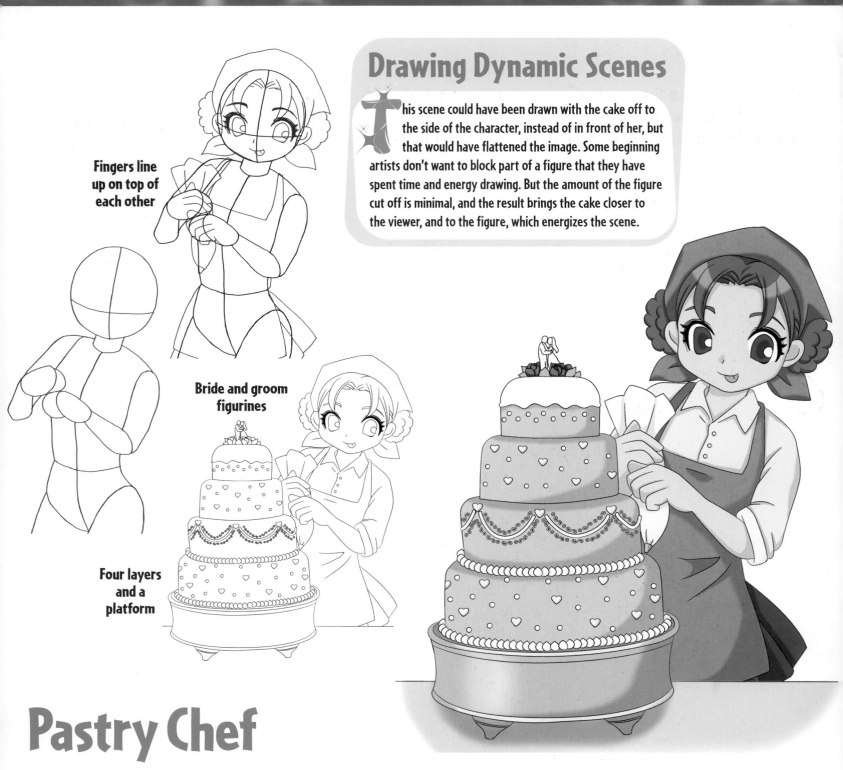

Fingers line up on top of each other

Bride and groom figurines

Four layers and a platform

Pastry Chef

I don't know about you, but it always looks like so much fun when I see a pastry chef adding squiggles of icing along the edges of a cake. I'd never try it, though—I'd probably misspell a word and try to fix it with a pencil eraser, and I hear that doesn't work too well on icing!

Pizza Maker

This chef's outfit is all white, with a chef's hat that leans to one side. If it was any other color, all that white dough and flour would make huge white marks all over it. A raw pizza should be drawn as if it were a gigantic pancake, twirling unevenly in the air. Her hands are up, about shoulder height, as she releases the pie. She must follow the pie with her eyes, or she might end up wearing it!

Head tilts back to watch the pizza pie

Add motion lines

Hands at different heights to avoid symmetry

Unlike the French chef's hat, this one collapses to the side

Coloring "White" Costumes

Here's a little tip: Even if a costume is meant to be white, it's usually drawn as a color. This chef's white outfit is actually a pale blue accented with light blue highlights. If it were left completely white, it would look blank, as if the colorist had forgotten to work on it and left it empty! It might look like a mistake, unless, of course, you were working in black and white, in which case it would be fine to leave it white.

We've dressed her up as a cowgirl with a wide-brimmed hat and short pigtails with ribbons.

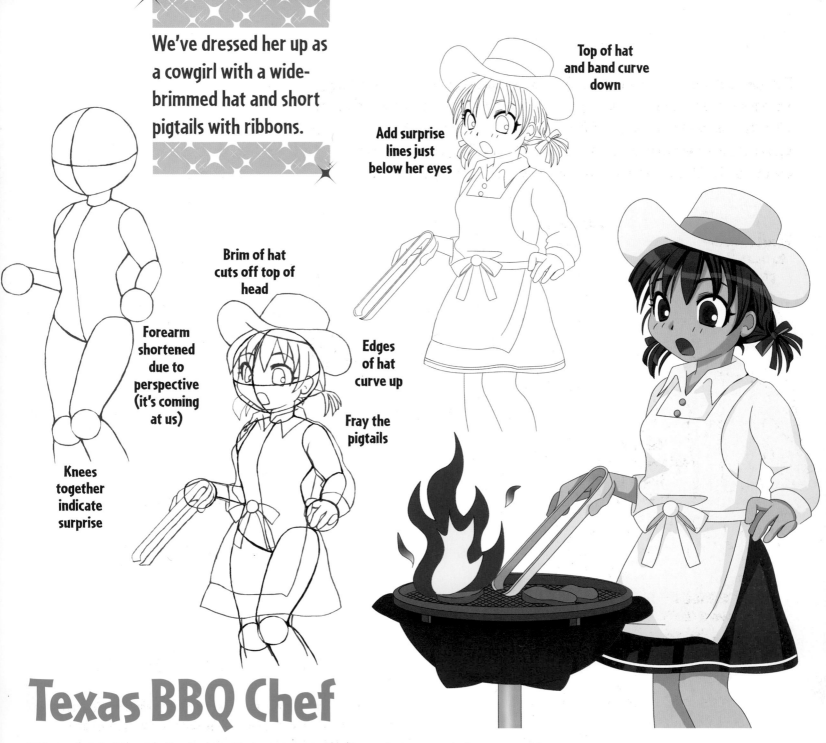

Top of hat and band curve down

Add surprise lines just below her eyes

Brim of hat cuts off top of head

Forearm shortened due to perspective (it's coming at us)

Edges of hat curve up

Fray the pigtails

Knees together indicate surprise

Texas BBQ Chef

This novice chef needs a few lessons in the fine art of grilling. Looks like she cheated and used some quick starter fluid, and a bit too much of it at that. One thing's for sure: No one's going to have a tough time recognizing that those burgers were charbroiled. Show the whites of her eyes and give her a tiny mouth, for a surprised expression!

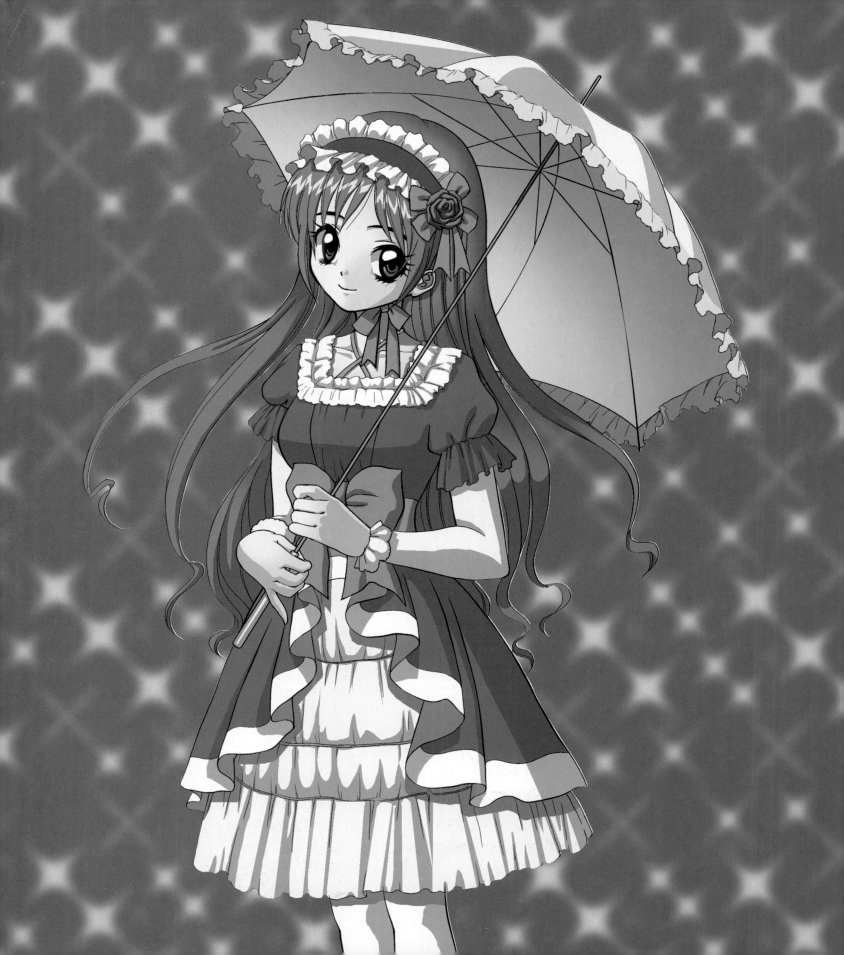

Gothic and Frilly Girls

There is a very popular movement in Japanese fashion that is spreading to the U.S. and around the world. Inspired by Victorian and Edwardian fashions, girls and young women dress in outfits that range from gothic to elegant to sweet and feature tons of ruffles, bows and frills. These ladies are at the very cutting edge of fashion, and characters based on them are popping up in manga and anime. And, boy, do they like to dress up—the more "stuff" you can add to these characters, the better!

Dress-Up Doll

Is she expecting sun or rain? Neither, but she saw this really cool umbrella at a thrift shop and it went so well with her outfit that she just had to have it! If you enjoy drawing frilly ruffles and flounces, you're going to love this style. This girl sports a distinctive "doll" look that is created by the lacy dress she wears and the prim and proper pose she assumes.

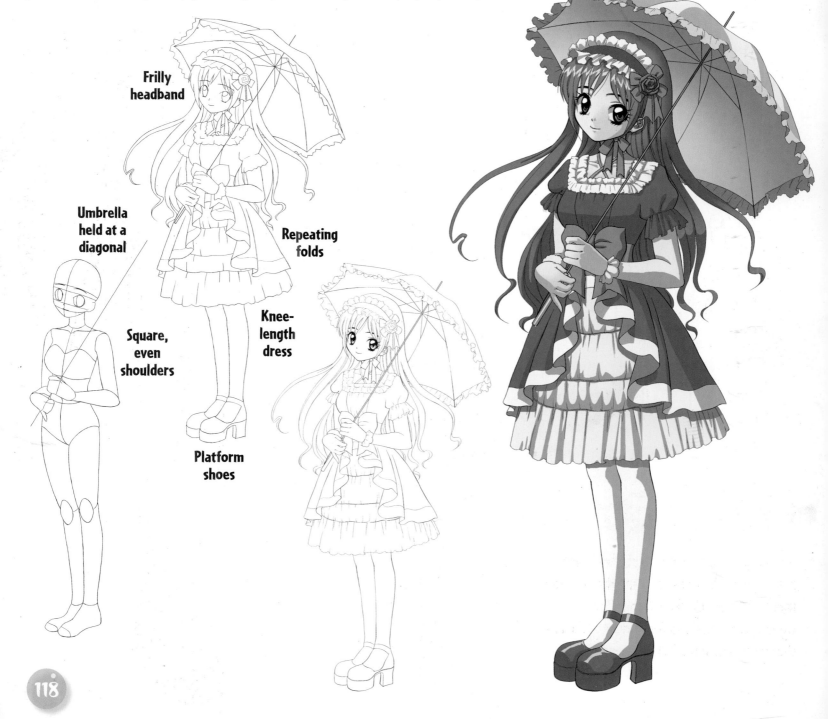

Frilly headband

Umbrella held at a diagonal

Square, even shoulders

Repeating folds

Knee-length dress

Platform shoes

Body language is key to communicating expression. Her flirty stance is perfect for this look. How do you capture it in your drawing? It's all about posture. She lifts one shoulder up toward the chin (the bent arm) while lowering the other shoulder (the straight arm). One leg is straight, while the other one is expressively bent at the knee.

Magical girl-style hairdo

Leggings

Platform shoes

Pretty Goth

On the opposite side of the coin, we have the pretty goth, who doesn't wear quite so many layers of ruffled clothing. Instead, her clothing is minimal and formfitting, although she still retains some frills here and there.

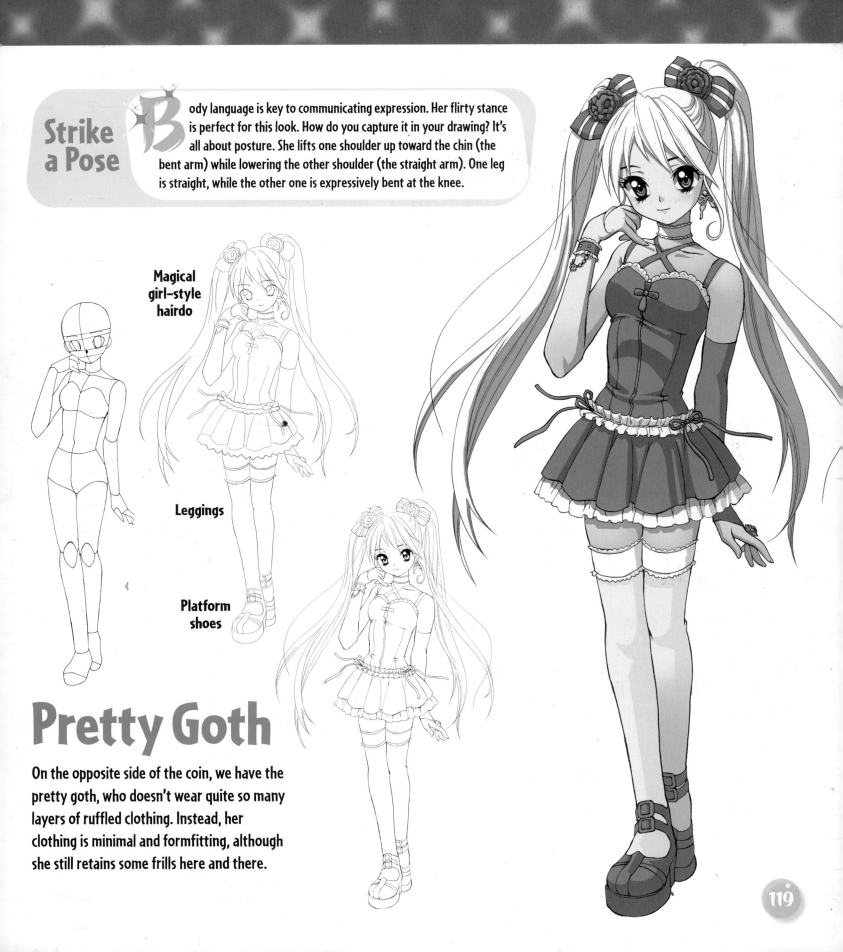

Urban Goth

The leather jacket says downtown Tokyo. Make it heavy leather, like a biker jacket. How do you indicate that? By giving it a big leather belt and buckle, and by showing the thickness (dimension) of the collar. And add a pouch and zippers. Yep, it's got the whole nine yards. But you can tell she's an urban goth, not a biker gal, because she's wearing a lacy dress under the jacket. Plus, these girls are still cute shojo characters. Real biker gals may be many things, but "cute" is not one of them.

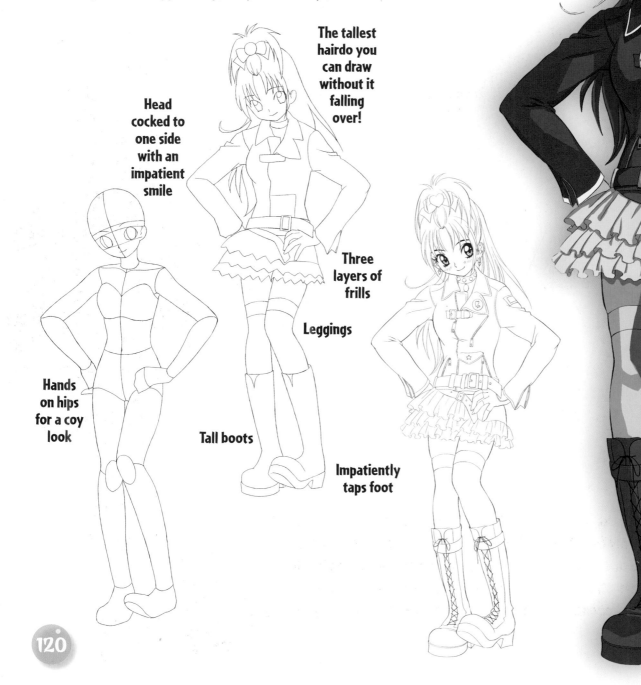

Head cocked to one side with an impatient smile

The tallest hairdo you can draw without it falling over!

Hands on hips for a coy look

Three layers of frills

Leggings

Tall boots

Impatiently taps foot

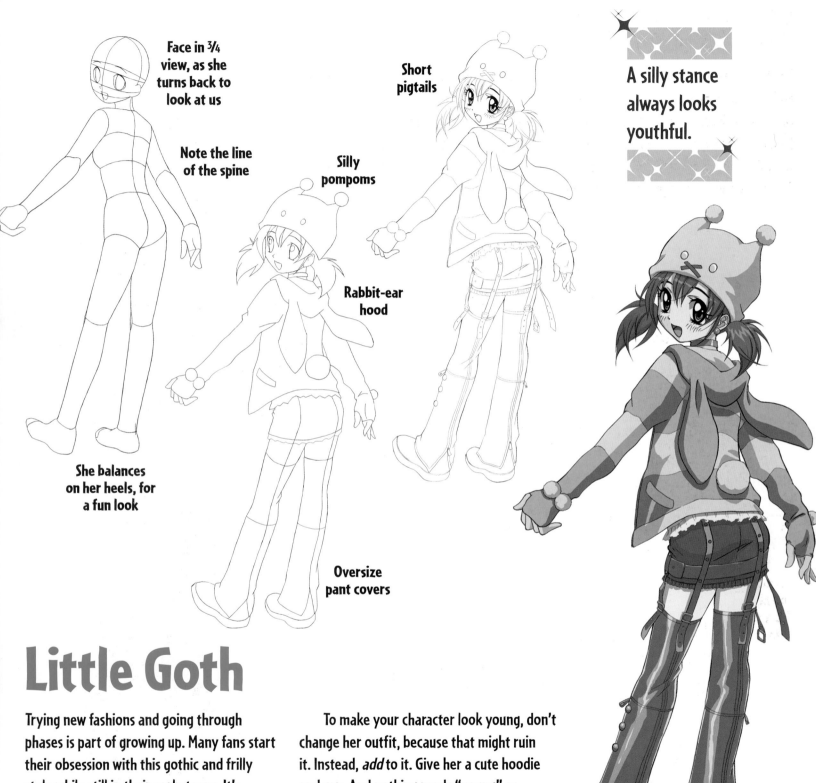

Face in ¾ view, as she turns back to look at us

Note the line of the spine

She balances on her heels, for a fun look

Silly pompoms

Rabbit-ear hood

Oversize pant covers

Short pigtails

A silly stance always looks youthful.

Little Goth

Trying new fashions and going through phases is part of growing up. Many fans start their obsession with this gothic and frilly style while still in their early teens. It's a cosplay favorite at manga conventions.

To make your character look young, don't change her outfit, because that might ruin it. Instead, *add* to it. Give her a cute hoodie and cap. And nothing reads "young" as quickly as a set of animal ears or pompoms.

Dress It Up!

Now let's go in for some close-ups to get a good look at different hairstyles and accessories, collars, straps and all the things that make the gothic and frilly style so appealing. Remember, these outfits are the ultimate in over-the-top dressing up, which is part of the reason girls like them so much!

Frilly Headband

Note the rosette detail on the side and how the headband ties under the chin. This look is oh-so-demure and feminine.

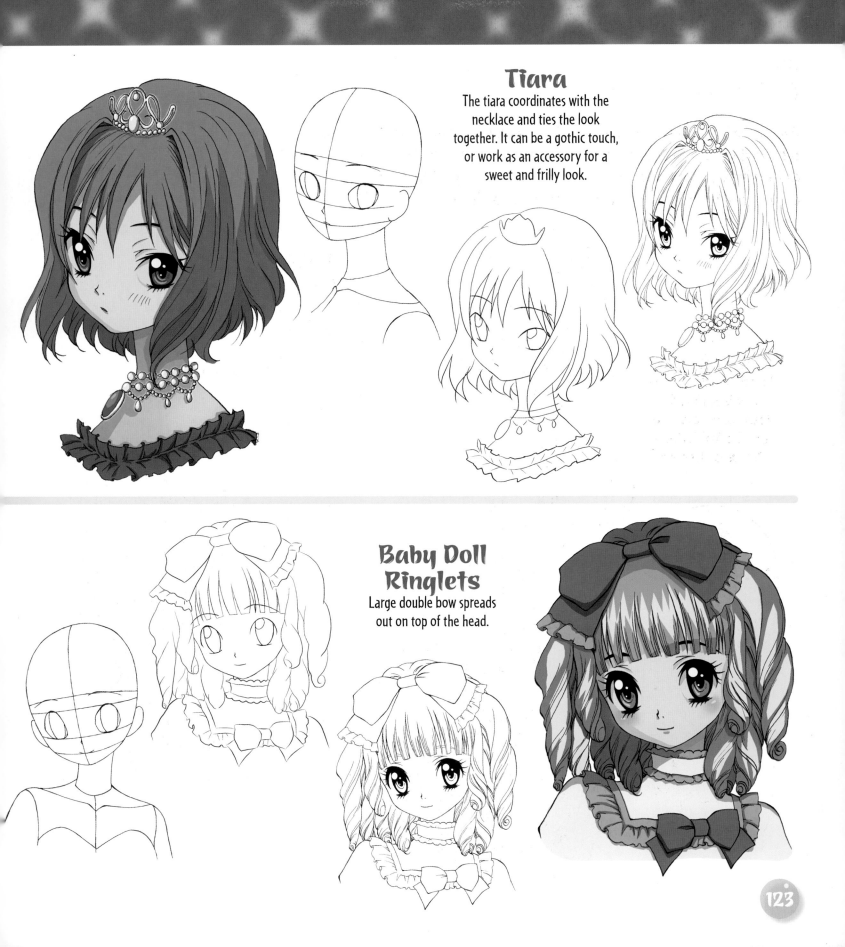

Tiara

The tiara coordinates with the necklace and ties the look together. It can be a gothic touch, or work as an accessory for a sweet and frilly look.

Baby Doll Ringlets

Large double bow spreads out on top of the head.

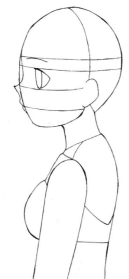

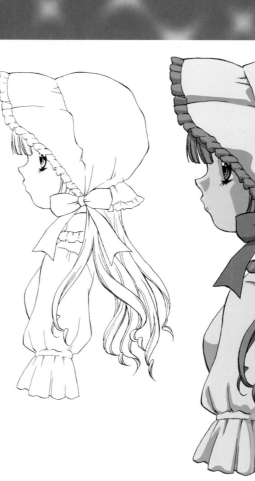

Bonnet

At first glance, she looks like a sweet and frilly girl, but she could just as easily be drawn as a gothic character in an occult story, riding in a horse-drawn carriage up to a vampire's castle. The bonnet gives her a spooky 1800s look.

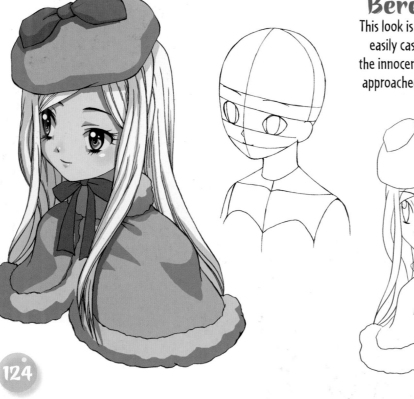

Beret and Cape

This look is super-cute. Again, you could easily cast her in a vampire story as the innocent bystander who is suddenly approached by the Prince of Darkness.

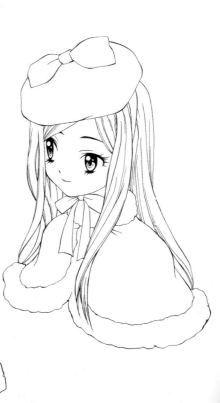

All Gothic, All the Time

No doubt about this one. She's completely goth. The bare shoulders and all those straps scream "gothic." But she's not a goth in the sense of being a dark and troubled character. In this genre, the characters are bubbly and appealing, and don't have to spend Thursday afternoons at their therapist's office.

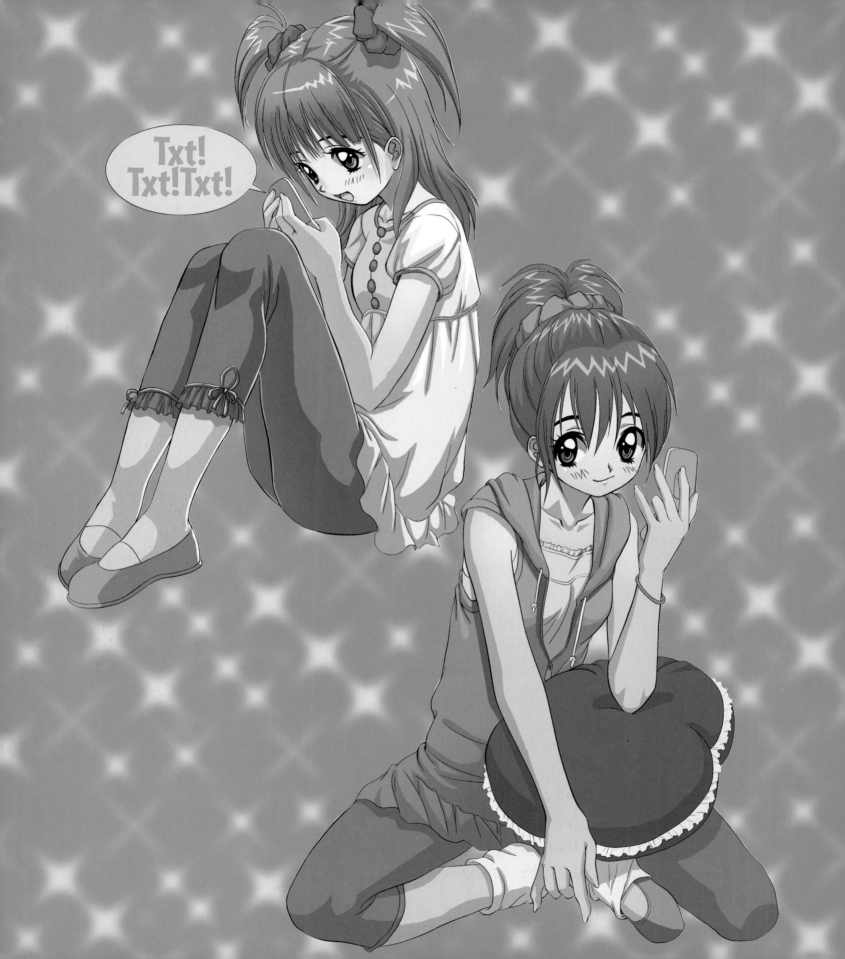

Slice of Life!

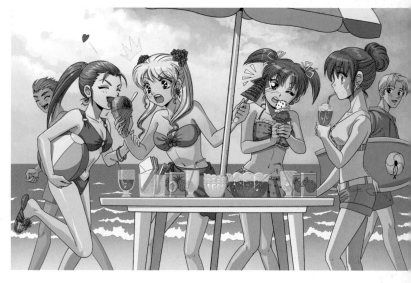

Many popular manga graphic novel series fall into the "slice of life" category. Stories in this genre include characters in everyday situations, dealing with the ups and downs of friendships and relationships. These stories are touched with humor. And like life itself, there are often surprising twists and turns in the plot lines. The characters who star in these stories are just like you and your friends. They're real people, which makes it easy for readers to identify with them.

Everyday Stuff

The slice-of-life genre is made up of little scenes from daily life. Since the characters wear everyday clothing, we concentrate more on body language than on wardrobe to evoke emotions. So let's focus on working those poses. We'll cover all the special tricks you'll need to make sure they come out right.

Txt! Txt!Txt!

Place cell phone close to face—it's hard to read!

Body is curled

Don't forget to draw the far thigh

Tips of feet should touch

Arm goes across body at a diagonal

Foot and elbow align

Txt! Txt!Txt!

Nonstop Texting!

Don't try to get between a teenage girl and her cell phone—that's a dangerous place to be! When she's texting, she curls up with her phone, almost as if it were a good cup of coffee. It's fun, but sort of a private thing, too. So she's protective of it, and her body language shows it. She pulls away into her own world—just her and her 85,000 best friends.

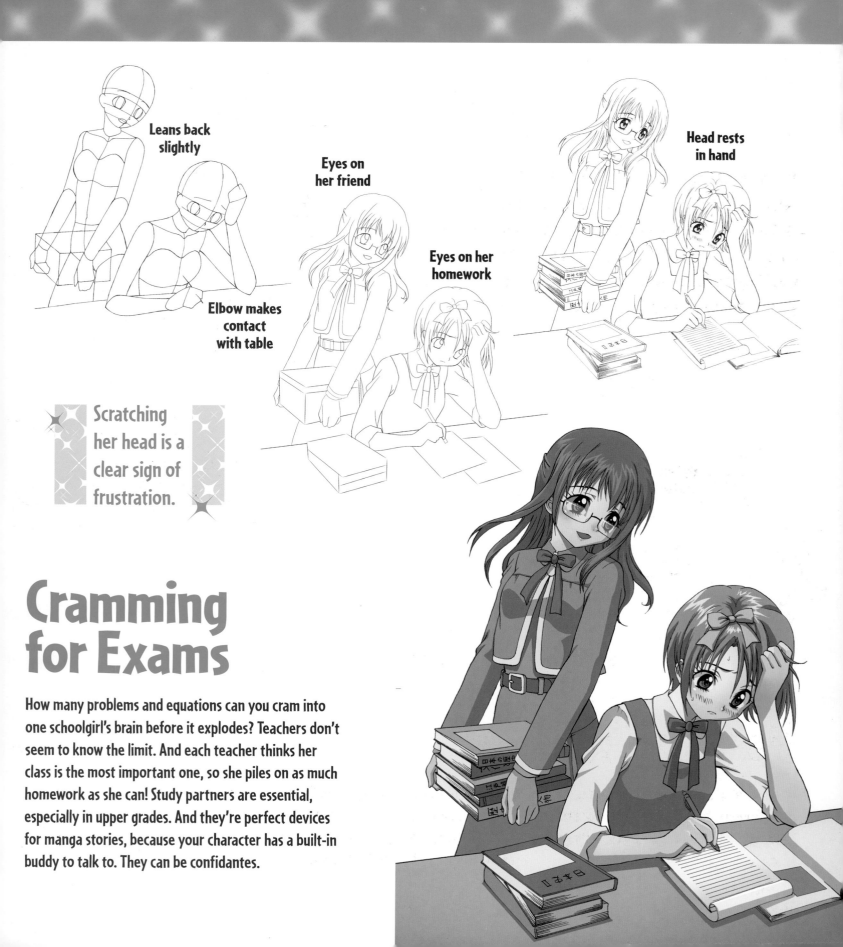

Leans back slightly

Elbow makes contact with table

Eyes on her friend

Eyes on her homework

Head rests in hand

Scratching her head is a clear sign of frustration.

Cramming for Exams

How many problems and equations can you cram into one schoolgirl's brain before it explodes? Teachers don't seem to know the limit. And each teacher thinks her class is the most important one, so she piles on as much homework as she can! Study partners are essential, especially in upper grades. And they're perfect devices for manga stories, because your character has a built-in buddy to talk to. They can be confidantes.

Primping

Girls can be very competitive, especially in the slice-of-life genre, and they like to look good so other girls won't gossip about them. Watch out when they're getting ready for a date. All the stops are pulled out. Nerves heighten. Hair becomes as important as world peace. Even a hint of a blemish is more devastating than a low score on the SAT. And her little brother waiting desperately to use the bathroom? He's simply collateral damage.

Working on an Updo

Hair Braiding

Brushing Her Hair

Girls and Their Pets

Pets, especially dogs and cats, are featured in many manga stories. Just like people, dogs and pups come in all shapes and sizes. Some of the small ones travel in purses. The big ones drag their owners by the leash. And of course, there are the cats, which believe that any surface—including their owners—is okay to climb on. These adorable sidekicks add some zing to the cast of human characters.

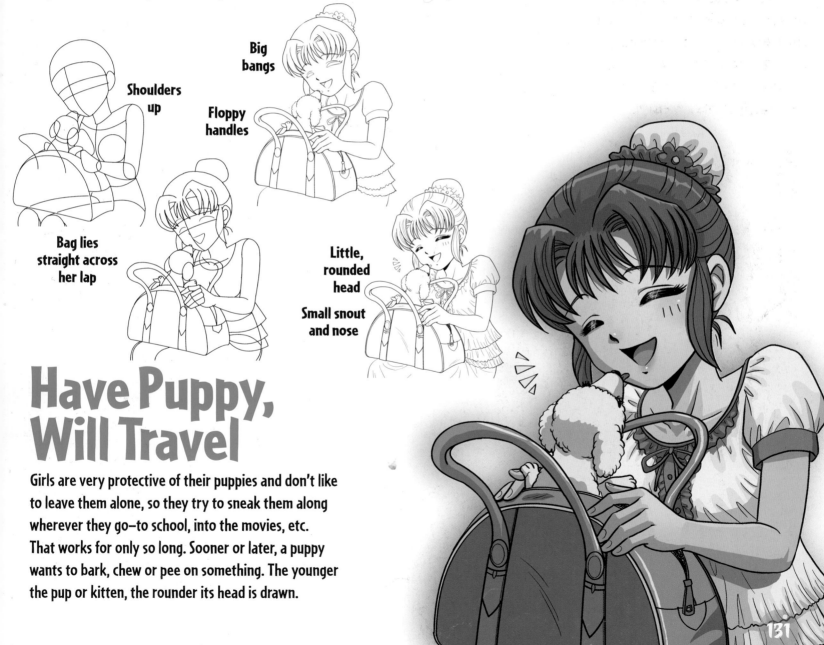

Shoulders up

Bag lies straight across her lap

Big bangs

Floppy handles

Little, rounded head

Small snout and nose

Have Puppy, Will Travel

Girls are very protective of their puppies and don't like to leave them alone, so they try to sneak them along wherever they go—to school, into the movies, etc. That works for only so long. Sooner or later, a puppy wants to bark, chew or pee on something. The younger the pup or kitten, the rounder its head is drawn.

131

BigDog!

Ever walk a dog like this? He will enjoy it, but you won't. Forced perspective is at work in this drawing. This means that part of the image is forced to enlarge quickly to exaggerate its size. In this case, the dog appears unusually large relative to the girl in order to emphasize his size and strength. See how forced perspective increases the size of his front paws? And the dog's head, which is in reality no bigger than a human's, is drawn much larger than hers.

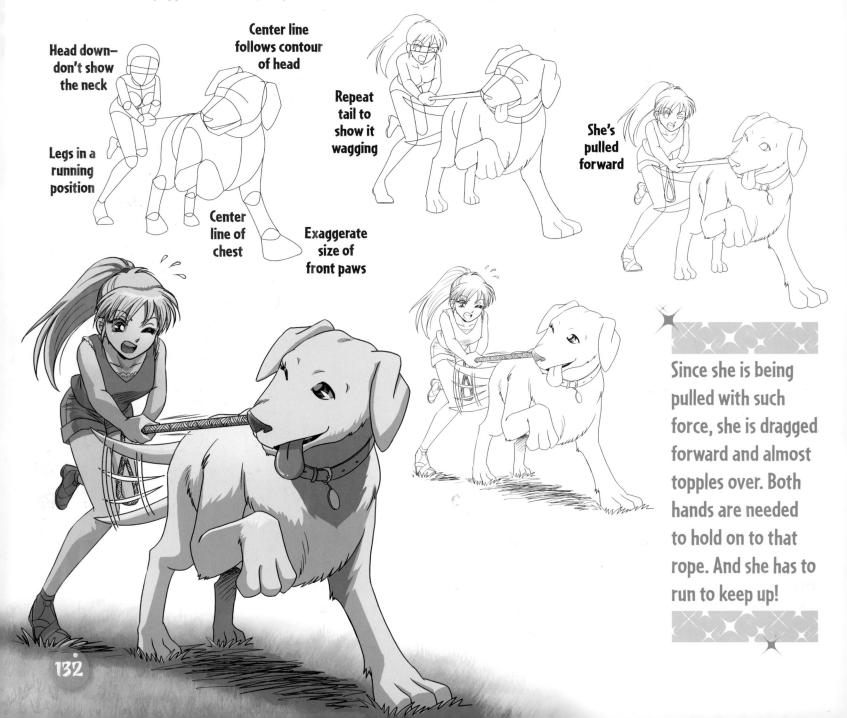

Head down—don't show the neck

Center line follows contour of head

Legs in a running position

Repeat tail to show it wagging

Center line of chest

Exaggerate size of front paws

She's pulled forward

Since she is being pulled with such force, she is dragged forward and almost topples over. Both hands are needed to hold on to that rope. And she has to run to keep up!

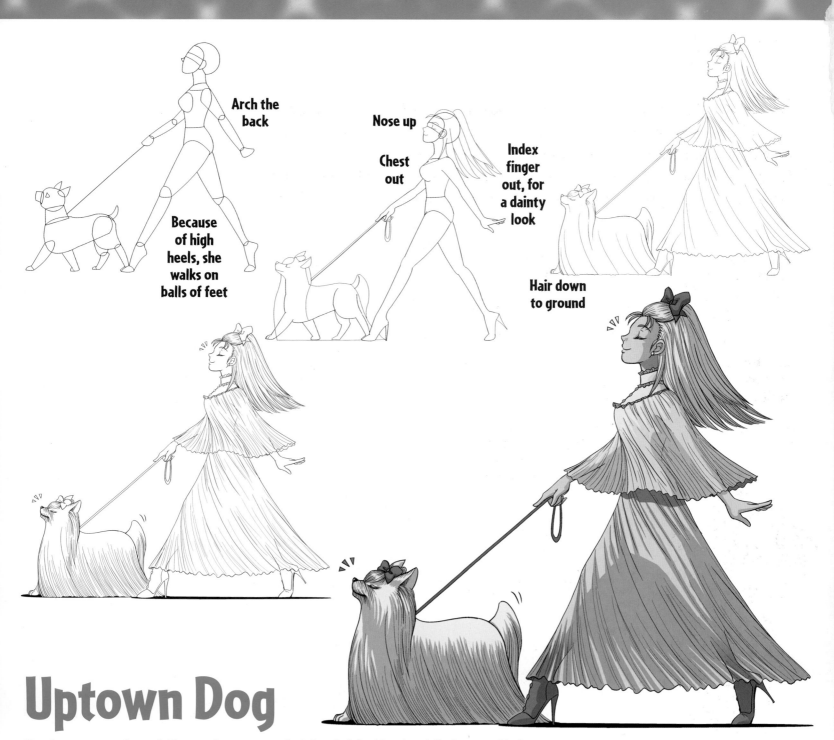

Arch the back

Nose up

Chest out

Index finger out, for a dainty look

Because of high heels, she walks on balls of feet

Hair down to ground

Uptown Dog

Here's a pampered pooch if ever there was one. Both dog and owner have the same posture–back arched, nose up in the air– which makes the image funny. Each is well groomed, too. The dog's long, flowing hair is mimicked by the girl's dress and hair, tying them together visually. And they both have the same expression–small smile with eyes closed; they even share the same special effect over the forehead!

Kittens! Kittens! Kittens!

Well, these kitties are a bit confused. They think this girl is a scratching post with ears! But they're so cute, she'll let them do anything they want. Kittens get into all sorts of trouble, and there's just no way to keep them out of any "restricted" area of the house. Better just wave the white flag now—the kittens have taken over. While grown cats are often depicted as solitary pets, kittens work well in groups that play together. It just magnifies the adorable factor.

Her expression is a combination of surprise and delight: It's fun to have kittens climb all over you, but how the heck do you get them off?!?

Vary the kitten's expressions—this one has a big, bright smile with open eyes and mouth

This one is a bit concerned he's falling off!

And this one's eyes are closed in a wide smile

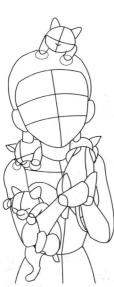

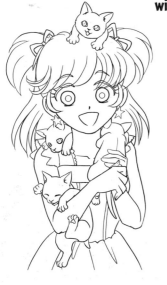

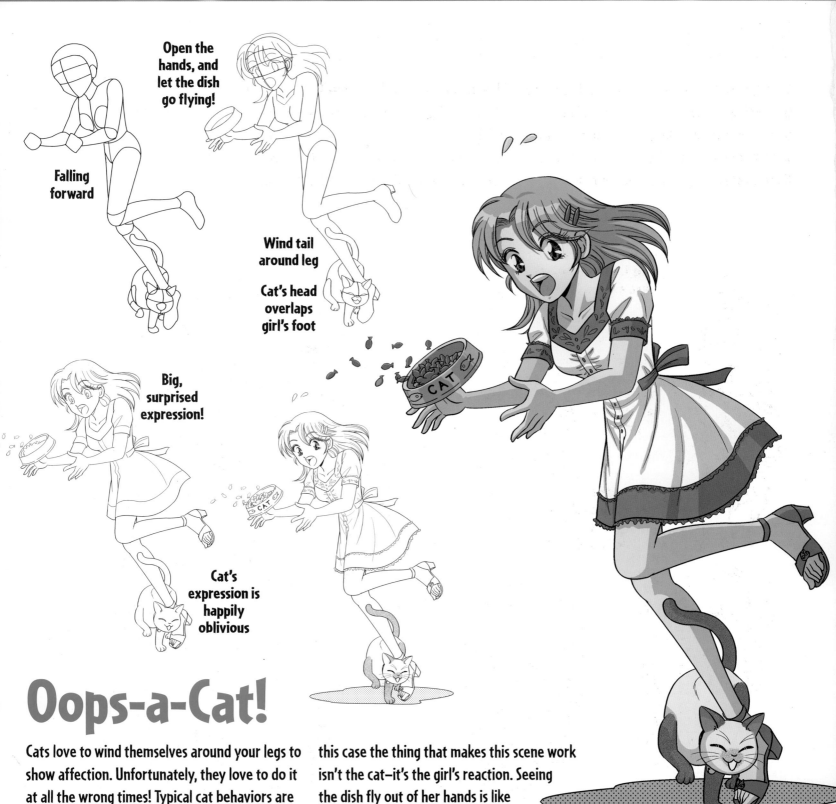

Open the hands, and let the dish go flying!

Falling forward

Wind tail around leg

Cat's head overlaps girl's foot

Big, surprised expression!

Cat's expression is happily oblivious

Oops-a-Cat!

Cats love to wind themselves around your legs to show affection. Unfortunately, they love to do it at all the wrong times! Typical cat behaviors are an opportunity to create funny moments, but in this case the thing that makes this scene work isn't the cat—it's the girl's reaction. Seeing the dish fly out of her hands is like watching a train wreck in slow motion.

Beach Party!

There are plenty of popular manga series that take place in school, but even manga characters like to take a break from school once in a while. So naturally, there are manga stories that take place at the beach, where teens gather for fun in the sun. Let's take a brief detour and draw some characters playing beach volleyball and splashing around.

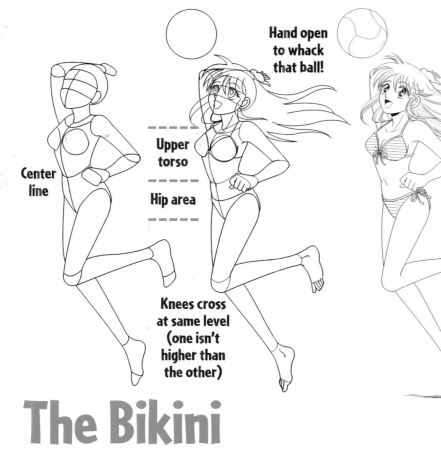

Center line

Upper torso

Hip area

Knees cross at same level (one isn't higher than the other)

Hand open to whack that ball!

The Bikini

When drawing people in bathing suits, you've got to pay special attention to the construction of the figures, because you've got nowhere to hide your mistakes. Drawing the center line down the body helps to anchor the torso in the right direction—in this case a 3/4 view. Notice how the body is drawn in two distinct sections: 1) the upper torso, and 2) the hips, just as you would see in a department store mannequin. This is the easiest way to draw the female figure.

One-Piece Bathing Suit

It may not look like it at first, but this is actually an easy pose to draw, because the head and upper body are facing us in a simple front view. As she runs toward the water (brave soul that she is!), draw one foot out in front and one lagging behind. The calf of the far leg should get smaller, due to perspective. That far leg partially hides behind the front leg. This overlapping action gives the pose some depth—and, happily, makes it easier to draw.

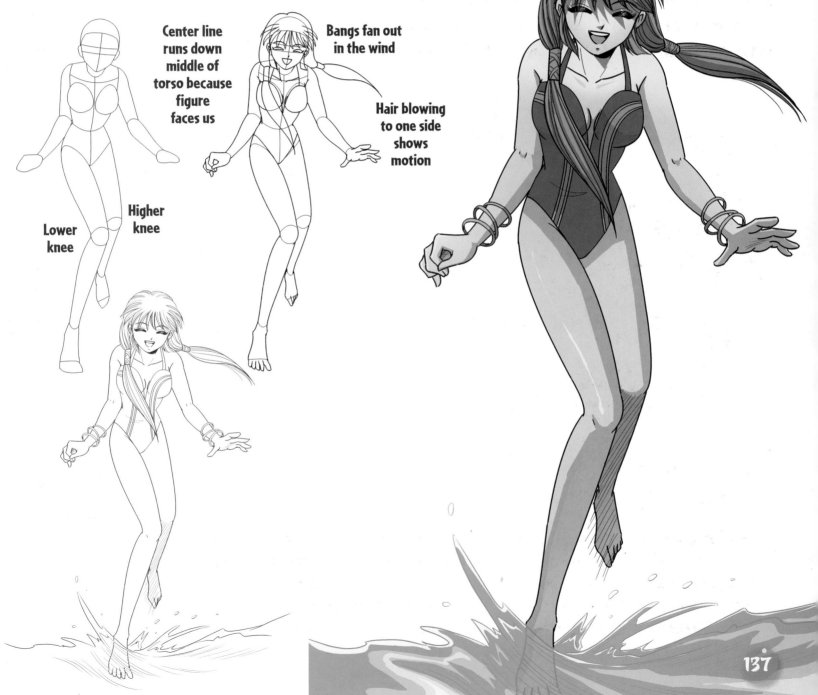

Center line runs down middle of torso because figure faces us

Lower knee

Higher knee

Bangs fan out in the wind

Hair blowing to one side shows motion

Summer Picnic on the Sand

A good composition is one that leads the eye from one person to the next in an uninterrupted row, like dominoes. Either way your eyes scan this picture, left to right (American style), or right to left (Japanese style), the action flows smoothly.

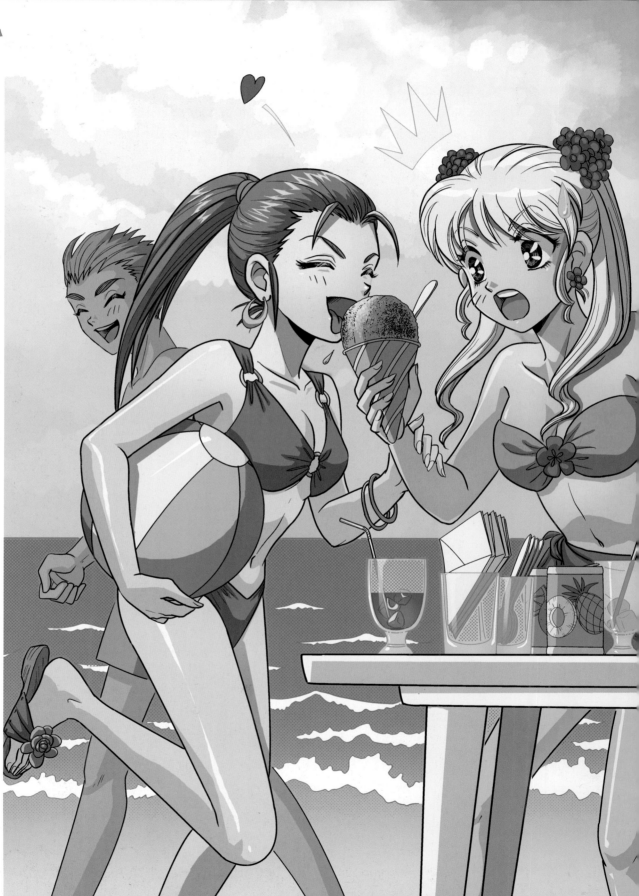

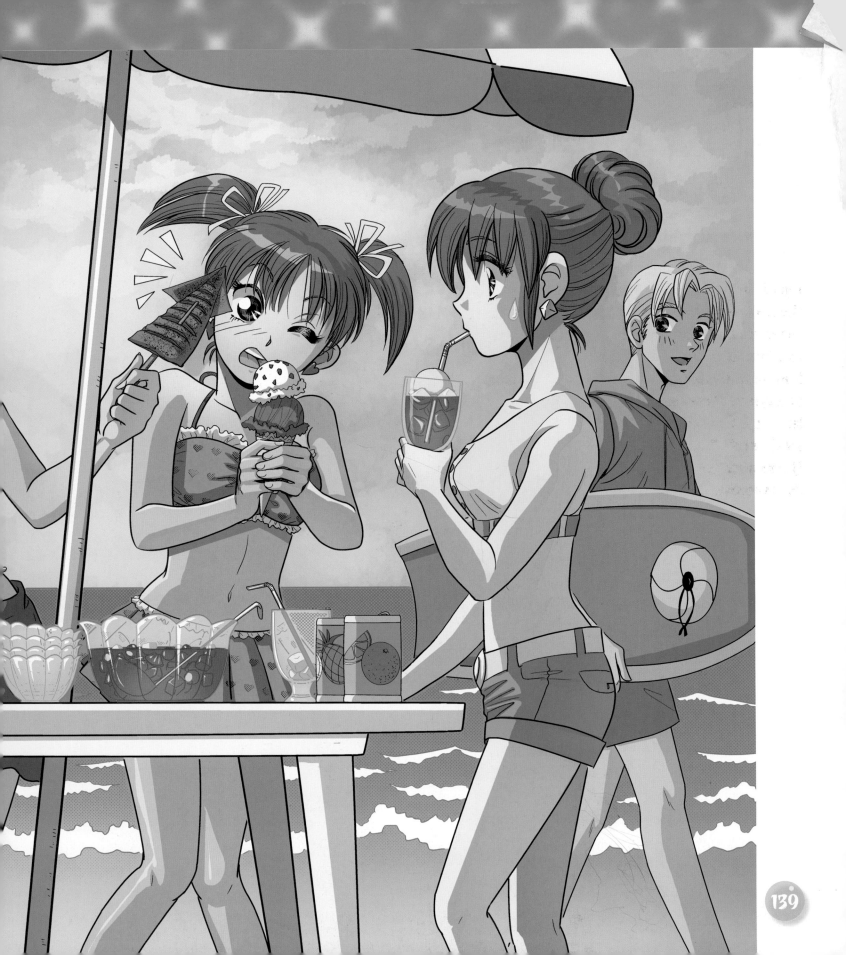

Boy Crazy!

Crushes bring out quirky traits in otherwise sane girls—some get silly and embarrassed, while others get jealous and possessive. Pity the poor boy, who is usually clueless. At this awkward age, the girl's attempts to capture the boy's attention don't usually work on the first try. She's either too forward or too subtle. But that's what makes for great romance stories.

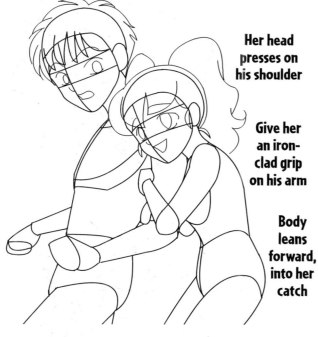

Her head presses on his shoulder

Give her an iron-clad grip on his arm

Body leans forward, into her catch

Possessive Type

Um, do you think she's a little too forward, maybe? Nah. She just likes to be with him all the time. And I do mean ALL the time. Day and night, wherever he goes. And you know just how much 15-year-old boys like to have their girlfriends tag along when they hang out with their pals. Pretty soon, he's going to resort to hiding in the school stairwells!

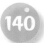
140

Shy Girl

If he were to actually speak to her, she'd probably have to run away. All young teen romances begin slowly and are filled with false starts, miscommunications and other complications. For example, the popular girl might have just broken up with this guy. But seeing our star character (the girl in this picture) give him homemade (albeit slightly burnt) cookies makes her so jealous that now she wants him back! Whom will he choose? Ah yes, love is never easy.

Bring shoulders up for shy body language

Palm heels together as hands cradle chin

Her eyes close and blush marks appear as she turns away from her true love.

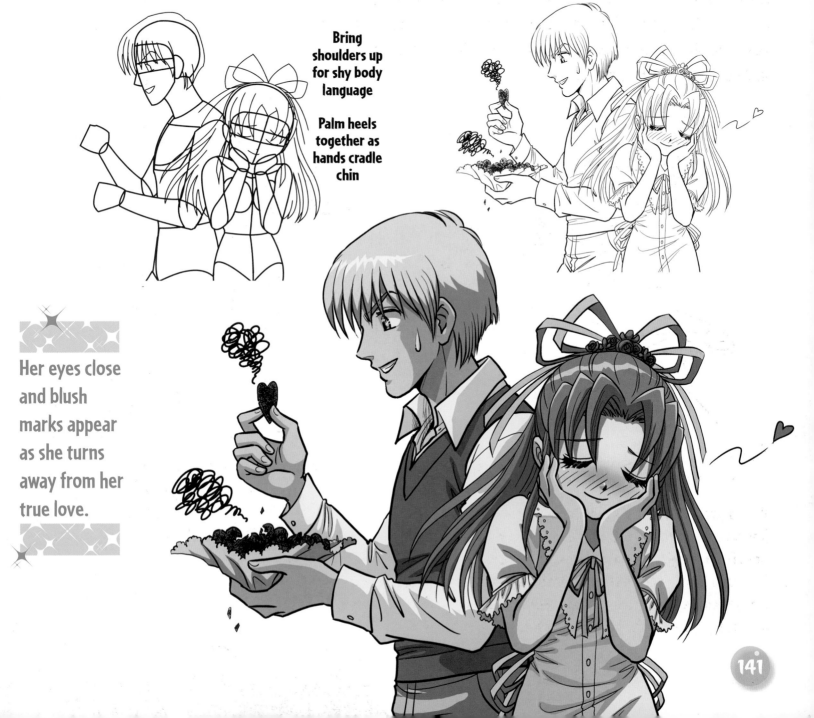

So Embarrassing!

She likes him, but he'll never know it, because she's too embarrassed to send any signals to that effect. She's just too self-conscious. In fact, he misreads her reactions to him as disliking him. "Why does she hate me?" he wonders, when, in fact, it's exactly the opposite.

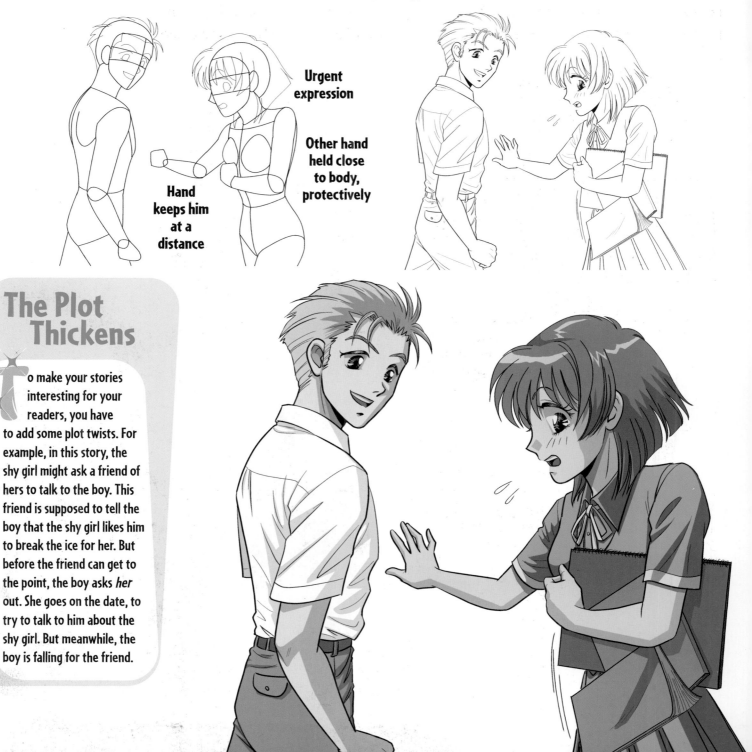

Urgent expression

Other hand held close to body, protectively

Hand keeps him at a distance

The Plot Thickens

To make your stories interesting for your readers, you have to add some plot twists. For example, in this story, the shy girl might ask a friend of hers to talk to the boy. This friend is supposed to tell the boy that the shy girl likes him to break the ice for her. But before the friend can get to the point, the boy asks *her* out. She goes on the date, to try to talk to him about the shy girl. But meanwhile, the boy is falling for the friend.

Giggly Girl

This one gets so tickled by being next to the guy she likes that she can't stop giggling. He likes her too, but is running out of patience, because how can you talk to a girl who won't stop tittering? And he knows he's not *that* funny. Boys are insecure, too. Maybe she's laughing at him, he wonders. Actually, she's just nervous. When people giggle, their heads go down. When they laugh uproariously, their heads go back. Giggly eyes are always drawn shut, and curving downward.

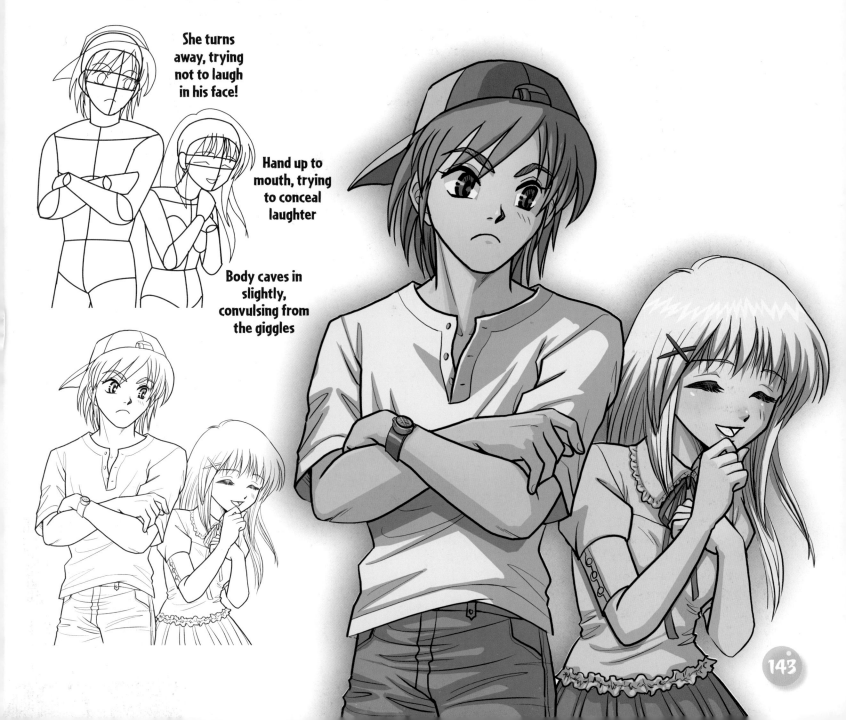

She turns away, trying not to laugh in his face!

Hand up to mouth, trying to conceal laughter

Body caves in slightly, convulsing from the giggles